W9-CBC-035

2

Mirrors and Windows
American Photography since 1960

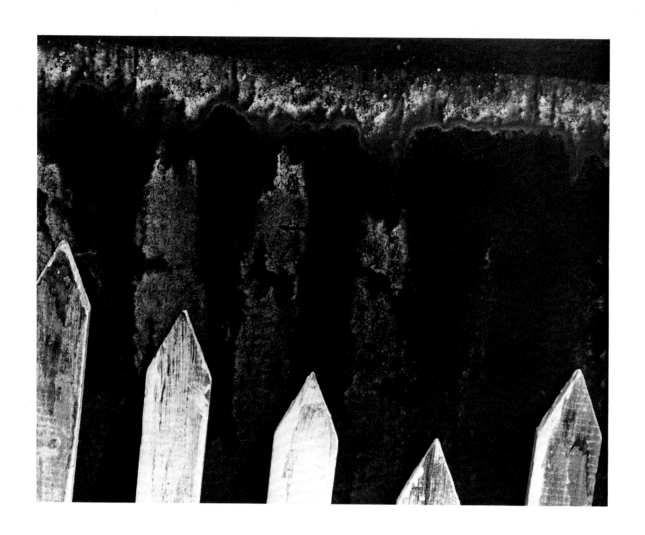

WALTER CHAPPELL
Number 10, 1958
10⅜ x 13¼ inches
The Museum of Modern Art, New York
Gift of the photographer

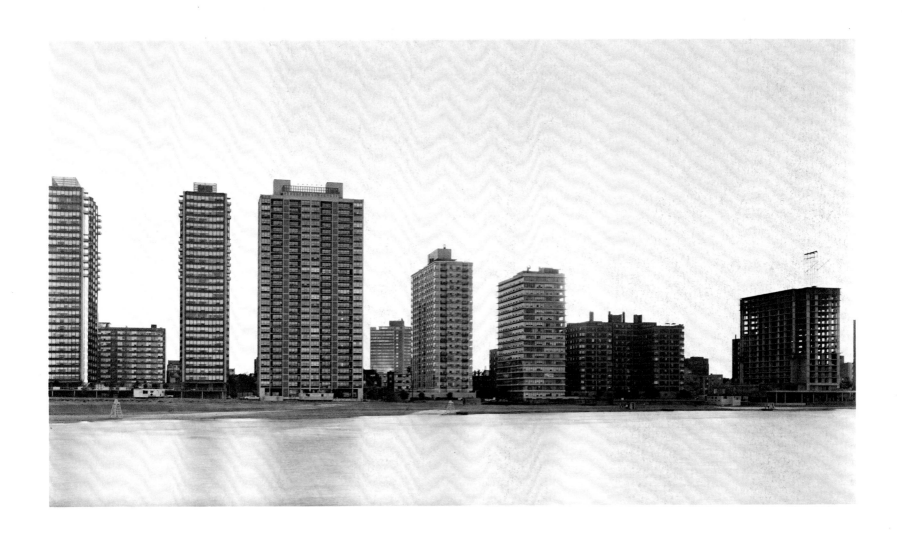

Art Sinsabaugh
Chicago Landscape #299. 1966
10⅝ x 19¼ inches
The Museum of Modern Art, New York
Purchase

Mirrors and Windows
American Photography since 1960

John Szarkowski
The Museum of Modern Art, New York

Distributed by New York Graphic Society, Boston

This book has been published on the occasion of an
exhibition at The Museum of Modern Art and has been made possible
through the generous support of Philip Morris Incorporated
and the National Endowment for the Arts

Schedule of the exhibition:

THE MUSEUM OF MODERN ART, NEW YORK
July 28 – October 2, 1978

CLEVELAND MUSEUM OF ART
November 13, 1978 – January 1, 1979

WALKER ART CENTER, MINNEAPOLIS, MINNESOTA
January 29 – March 11, 1979

J. B. SPEED ART MUSEUM, LOUISVILLE, KENTUCKY
April 1 – May 15, 1979

SAN FRANCISCO MUSEUM OF MODERN ART
June 7 – July 29, 1979

UNIVERSITY OF ILLINOIS, KRANNERT ART MUSEUM, CHAMPAIGN, ILLINOIS
August 19 – September 23, 1979

VIRGINIA MUSEUM OF FINE ARTS, RICHMOND, VIRGINIA
November 12 – December 23, 1979

MILWAUKEE ART CENTER
January 10 – March 2, 1980

Designed by Patrick Cunningham
Type set by David Seham Associates, Metuchen, New Jersey
Printed by Rapoport Printing Corp., New York, New York
Bound by Sendor Bindery, Inc., New York, New York

The Museum of Modern Art
11 West 53 Street, New York, New York 10019
Printed in the United States of America

Acknowledgments

On behalf of the Trustees of The Museum of Modern Art, I gratefully acknowledge the generous grants from Philip Morris Incorporated and from the National Endowment for the Arts that have made possible this book and the exhibition it accompanies.

The lenders who have graciously allowed works from their collections to be reproduced here are identified on the pages where their pictures appear, as are the names of the many donors whose gifts to the Museum's Collection are represented.

Many people have assisted with the basic research for this project. Tom Garver and Robert Heinecken must be specifically thanked for their exceptionally generous efforts to acquaint the author with current work from the West. If this book inadequately represents that work, the fault is mine, not theirs.

Betsy Jablow, Beaumont and Nancy Newhall Fellow in the Museum's Department of Photography, has been of indispensable help in the preparation of both the book and the exhibition. Her opinions on issues of critical substance, and those of Susan Kismaric, have been deeply valued.

As editor of the introductory essay, Jane Fluegel has been gracious and tolerant; she should not be held responsible for any eccentricities of syntax or punctuation that may remain.

Most of all, I would like to thank the thousands of photographers who have over the years allowed the Museum to see their work in progress, and who have thus been my teachers. To the degree that I have understood that work, they have defined the substance of this book.

J.S.

Mirrors and Windows
American Photography since 1960

In this book I hope to provide a balanced but critically focused view of the art of photography as it has evolved in the United States during the past two decades. I hope, in other words, to be not only just but clear. In those circumstances where there seems a conflict between the two goals, I will try my best to favor clarity, on the grounds that clear error may be more instructive than vague truth.

The book is a selection of 127 pictures that seem exemplary of the work of American photographers who have come to public attention during the past twenty years. This definition excludes such major contemporary figures as Ansel Adams, Harry Callahan, Irving Penn, Aaron Siskind, Frederick Sommer, and others whose work was already a significant force by 1950 or earlier.

The pictures included here are arranged in two sections. This arrangement is designed to illustrate a critical thesis which I hope may offer a simple and useful perspective on the bewildering variety of technical, aesthetic, functional, and political philosophies that characterize contemporary photography's colloquium. This thesis suggests that there is a fundamental dichotomy in contemporary photography between those who think of photography as a means of self-expression and those who think of it as a method of exploration. This idea will be argued later in this essay.

The changes in American photography during the past twenty years have been profound, and go to the root issue of the photographer's definition of his function. In large part these changes are the expression of mutations in the professional circumstances and artistic environment in which the photographer works. To understand better the significance of these recent changes it would be useful to review the situation of photography during the preceding period, with special attention to the crucial decade of the fifties.

The general movement of American photography during the past quarter century has been from public to private concerns. It is true that much of the most vital photography done in this country during the preceding period was also essentially private. The work of Alfred Stieglitz and Edward Weston made concessions neither to the large concerns of public polity nor to the small ones of public taste, and although Paul Strand insisted in his written credos that social morality was the ultimate measure of an artist, only his most determined followers could discern a clear connection between his work and his stated philosophical position.

There were, however, others of the period—photographers whose work was in fact much more widely known—who provided an alternative model. Edward Steichen's brilliant celebrity portraits, illustrations, and fashion photographs provide a conspicuous example. Only slightly less well known, and in a comparable idiom, was work by Cecil Beaton, George Platt Lynes, Louise Dahl-Wolfe, Anton Bruehl, Paul Outerbridge, and others. Outside of the studio, a more radical definition of the photographer's role was being developed by Henri Cartier-Bresson, Bill Brandt, Margaret Bourke-White, Dorothea Lange, and others who consciously chose the politically and socially significant issues of the day as the raw material of their art. Each assumed that it was the photographer's function to act as a trustworthy interpreter of the events and issues he was privileged to witness. Many of the best of this group were European, but the natural home of their work was the popular magazine; thus its tradition was international rather than local.

For a quarter century the magazines gave promise of providing a structure that might accommodate an important part of the best of photography, that part directed toward issues of broad concern. It is this writer's impression that as late as the 1950s most young photographers of high ambition still considered the magazine a potential

EDWARD WESTON. *Detail, Abandoned Car, Mojave Desert*. 1937. The Museum of Modern Art, New York

DOROTHEA LANGE. *Refugees from Abilene, Texas*. 1936. Farm Security Administration

vehicle for their serious work. At the time it could still be felt that there was, possibly, a coincidence of interest between the creative photographer and the mass publisher. This faith was an expression of the ideal defined by Robert Frost: "My object in living is to unite/ My avocation and my vocation/ As my two eyes make one in sight." It was perhaps also a vestigial remnant of the traditional American distrust of the *amateur,* who was thought to be a dilettante of privileged station. Whatever its sources, it was a faith not easily apostatized; but by 1960, by imperceptible degrees, it had been largely lost. In 1960 magazines still existed that offered splendid opportunities to photograph events and places inaccessible to the free lance. But even when on such assignments, the photographer had come to focus his attention not simply on the form that his work would take in the magazine, but on the residual possibilities of book publication or exhibition, where he would be able to control more fully the meaning of his work. Or he could regard the assignment as a kind of unofficial travel grant, taking him to places where he could in his spare hours pursue his real photographic interests—making pictures of the stray dogs of the world, or the airports and motels in which he spent much of his life.

The relationship between serious photography and the magazines had been a troubled one from the beginning. The magazine offered the photographer challenging new problems and an enormous audience. In exchange it naturally expected editorial control of the photographer's work. This control was exercised not by means of dictatorial direction from the top, but rather by an increasingly bureaucratic committee system, under which editors, writers, researchers, art directors, and space salesmen all influenced the final shape and meaning of the photographer's published work. As the magazines grew older and their procedures more regular, it became increasingly difficult for even the most determined photographers to use the

magazine as a vehicle for their personal views of the world.[1] W. Eugene Smith came to be regarded as a patron saint among magazine photographers, not only because of the excellence of his work, but because he quit *Life* magazine in protest not once but twice, in 1941 and in 1954.

The reasons for the sudden decline and failure of the picture magazines are complex and numerous;[2] doubtless they include the success of television and cheap air travel, which made places and events familiar that as late as the fifties were still sufficiently exotic to hold the interest of most of us, even in the simplistic form in which the magazines presented them. It is also possible that the picture magazines failed because they were somehow not good enough. In retrospect it would seem that *Life* magazine was less successful as its ambitions became grander. Margaret Bourke-White's essay on the workers who built Fort Peck Dam[3] seems better as art and more dependable as reportage than her essays on the war in Russia.[4] Gene Smith's essay on a small town doctor in Montana[5] is less ambitious but ultimately more persuasive than his essay "Spanish Village,"[6] which attempts to illustrate the character of an ancient culture in seventeen photographs.

More recently, photography's failure to explain large public issues has become increasingly clear. No photographs from the Vietnam War—neither Donald McCullin's stomach-wrenching documents of atrocity and horror nor the late Larry Burrows's superb and disturbingly conventional battle scenes—begin to serve either as explication or symbol for that enormity.[7] For most Americans the meaning of the Vietnam War was not political, or military, or even ethical, but psychological. It brought to us a sudden, unambiguous knowledge of moral frailty and failure. The photographs that best memorialize the shock of that new knowledge were perhaps made halfway around the world, by Diane Arbus.

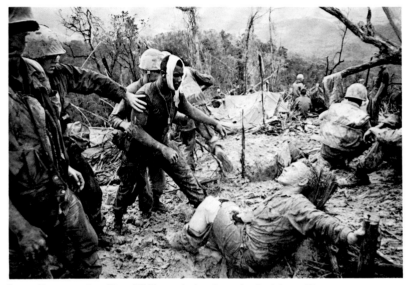

LARRY BURROWS. *At a First-Aid Center during Operation Prairie.* 1966. Original print in color. The Museum of Modern Art, New York. Gift of Time, Inc.

Photography's direct report of other recent matters of historical importance seems similarly opaque and superficial. The most widely published photograph from the civil rights movement of the sixties was a photograph of a police dog attacking a demonstrator. A photograph was made of Lee Harvey Oswald the moment after the bullet hit him; it shows a man surprised and in pain, but explains nothing of the minds of Oswald or Jack Ruby.

The failure of photojournalism stemmed perhaps from the sin of hubris. Like President Johnson, it thought it could deal with anything. This opinion was eventually proved fallacious in public. Good photographers had long since known—whether or not they admitted it to their editors—that most issues of importance cannot be photographed.

The decline of the picture magazines has been the most obvious example of the decay of professional opportunity for photographers, but it has not been the only, or the most widespread, example. Portraits, wedding pictures, scenic views, product photographs, PR photos, architectural views, insurance-claim documents, and a score of similar vernacular functions that were once thought to require the special skills of a professional photographer are now increasingly being performed by naïve amateurs with sophisticated cameras. Although for the most part these pictures are approximate and graceless, they answer adequately the simple problem of identifying a given face, setting, product, building, accident, or ritual handshake.

During the first century of his existence, the professional photographer performed a role similar to that of the ancient scribe, who put in writing such messages and documents as the illiterate commoner and his often semiliterate ruler required. Where literacy became the rule, the scribe disappeared. By 1936, when Moholy-Nagy declared that photography was the lingua franca of our time, and that the

illiterate of the future would be he who could not use a camera,[8] the role of the professional photographer was already greatly diminished from the days in which his craft was considered a skill close to magic. Today it is only in a few esoteric branches of scientific or technical work that a photographer can still claim mysterious secrets.

As the making of photographs became easy, and as this fact came to be understood, attention slowly shifted from craft to content.

The role of the professional is by nature social; his livelihood depends on the production of work that others find useful. As the influence of the professional diminished, the content of American photography became increasingly personal, and often progressively private.

It might seem ironic that the rapid decay of the traditional professional opportunities for photography has been paralleled by an explosive growth in photographic education, especially in the universities. In fact, an intuitive recognition that photography was ceasing to be a specialized craft (like stone carving), and becoming a universal system of notation (like writing), perhaps made it easier for educators to believe that it did fit within the proper boundaries of liberal education.

Prior to World War II, it was generally understood that one became a photographer through informal apprenticeship, self-instruction, or some mixture of the two. A few schools existed which were by courtesy of term called professional schools. In fact they were not quite trade schools in the traditional sense of the term; since photography was controlled by no licensing system, there was no given body of knowledge that had to be learned as the precondition for admission to practice.

Until the postwar years, photography was almost nonexistent in the

curricula of American universities. Rapid change began with the ambitious new art departments of the 1940s; that of the University of Iowa was perhaps seminal. These departments represented the encroachment of the universities into territory that had been the traditional province of the old professional art schools. This expansion of the university's role was defended on the grounds that artists would profit from being broadly educated, or, alternatively, that the truly educated person should have visceral as well as intellectual knowledge of the arts.[9] This double-edged argument proved irresistible, and the old professional academies quickly succumbed, or became the protectorates of larger, degree-giving institutions. In the more prosperous and more apostolic university environment, art curricula, enrollments, and faculty increased rapidly.

The more progressive of these new departments had included photography from the beginning, but the dramatic escalation of photographic education came during the decade of the sixties. As each generation of photography students received their Master of Fine Arts degrees, and were thus certified as teachers, new programs were begun in other institutions; enrollments tended to expand geometrically, and by 1970 it was an underprivileged institution indeed that did not offer at least undergraduate instruction in the art of photography. Between 1964 and 1967 the number of colleges and universities that offered at least one course in photography increased from 268 to 440.[10] In the years between 1966 and 1970 the number of students studying photography or cinematography at the University of Illinois (Champaign-Urbana) increased from 132 to 4,175—a growth of over three thousand percent in four years.[11]

A number of photographers of originality and significant achievement have come out of such programs. It would, however, be improper to measure the value of these programs by reference to such exceptional individuals; presumably the institutions themselves would not claim that talent is an attribute to be acquired in schools. In terms of the effect on photography of this educational venture, it might be more profitable to ask not what need it served, but rather what need it has created. There can be little doubt that these programs have increased enormously the number of people who believe, on the basis of their own experience, that photography is a very interesting art form. Thus it might be hypothesized that one of the by-products of photographic education has been the creation of an appreciative audience for the work of the student body's more talented teachers.[12]

Another significant side effect of the boom in photographic education has been its ecumenical influence on those artists who have taught in the schools. Painters, photographers, and printmakers have always been fascinated and influenced by each other's work, but in the new art schools an institutionalized proximity—and competition for money, enrollment, space, and staff—gave a new edge to the old curiosity. Artists who previously would have considered their disciplines to be mutually discrete became increasingly alert to the ideas, effects, and techniques that might be borrowed from one medium and persuaded to serve another. The line of such hybrid works goes back, within the modern tradition, at least to Moholy-Nagy, whose work and thought had an immense pedagogical influence on American art education during the postwar period.

In the fifties such borrowing was encouraged by the nagging sense of insecurity that occasionally troubled both photographers and traditional artists in their new university homes. The photographer was still suspect in some quarters because he claimed to make works of art with a machine; in response, photography's more doctrinaire champions answered that easel painting was an anachronistic handicraft, irrelevant to the twentieth century because it did *not* recognize the machine. Such arguments were taken more seriously in the universities than elsewhere.

For a photographer of liberal and open-minded inclination, it seemed reasonable to hedge the bet a little by drawing or painting on his photographs—or otherwise adding some evidence that he had hands as well as eyes. Similarly, for the painter and printmaker, the introduction into their works of photographic imagery or photographic techniques constituted clear evidence of modernity.

By whatever name one calls such works, they have been very important to those who call themselves photographers, painters, printmakers, or conceptual artists, and to those who find all such labels constricting. This book includes works by artists who do not think of themselves as photographers, or not essentially as photographers. I do not quarrel with their judgments. The subject of this book, however, is not photographers, but photography. To view the subject responsibly it is essential to consider first the character and influence of the work, rather than the persuasion of its maker.

In retrospect, perhaps the three most important events in American photography during the fifties were the founding of *Aperture* magazine (1952), the organization of ''The Family of Man'' exhibition (1955), and the publication of Robert Frank's *The Americans* (1959).[13] Of the three, only ''The Family of Man'' was a popular success. The enthusiasm with which it was received had rarely been accorded any exhibition, regardless of medium or subject. The exhibition was, in Jacob Deschin's words, ''essentially a picture story to support a concept . . . an editorial achievement rather than an exhibition of photography in the usual sense.''[14] As such, it was received with more reserved enthusiasm by photographers than by the general public. Although delighted to see photography so demonstratively appreciated, many photographers were distressed that the individual character of their own work had been sacrificed to the requirements of

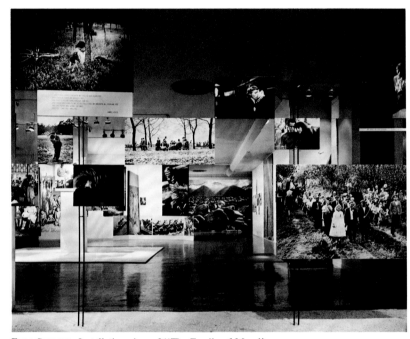

EZRA STOLLER. Installation view of ''The Family of Man,'' The Museum of Modern Art, New York, 1955

a consistent texture for the huge tapestry of the exhibition. Only those of philosophical disposition understood that the solution was artistically inevitable: the exhibition's basic theme—that all people are fundamentally the same—required that all photographs seem fundamentally the same.

In this sense "The Family of Man" was perhaps the last and greatest achievement of the group journalism concept of photography—in which the personal intentions of the photographer are subservient to a larger, overriding concept. The exhibition thus ran counter to the ambitions of the period's most original younger photographers; and in spite of its artistic quality and enormous success, it had little perceptible effect on the subsequent directions of American photography.

In contrast the quarterly review *Aperture* and Robert Frank's *The Americans* were both characteristic of the main thrust of the new photography of the fifties. In the views of their makers and their tiny audiences, the two publications undoubtedly represented very different visions of the art of photography. *Aperture,* which expressed the views of its chief founder and long-time editor Minor White (1908–1976), reflected values that had grown out of the American tradition defined by Alfred Stieglitz and enlarged by Edward Weston and Ansel Adams: a love for the eloquently perfect print, an intense sensitivity to the mystical content of the natural landscape, a belief in the existence of a universal formal language, and a minimal interest in man as a social animal. *The Americans*—Frank's searing personal view of this country during the Eisenhower years—was on the contrary based on a sophisticated social intelligence, quick eyes, and a radical understanding of the potentials of the small camera, which depended on good drawing rather than on elegant tonal description.

Nevertheless, Minor White's magazine and Robert Frank's book were characteristic of the new work of their time in the sense that they

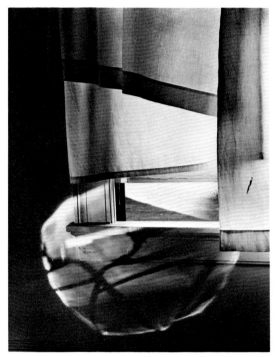

MINOR WHITE. *Windowsill Daydreaming.* 1958. The Museum of Modern Art, New York

ROBERT FRANK. *Butte, Montana.* 1955–56. Private collection

were both uncompromisingly committed to a highly personal vision of the world, and to the proposition that photography could, in aesthetic terms, clarify that vision. They were alike also in the sense that both avoided hortatory postures. Neither pretended to offer a comprehensive or authoritative view of the world, or a program for its improvement.

The values that White and Frank held in common defined the perimeters of thought and feeling that were available to the photographers of their time. The differences between them very nearly defined the range of options that were available within those boundaries.

White and Frank were, if not the best, surely the exemplary American photographers of the fifties. It is suggested here that their work can stand as a model for the fundamentally divergent concepts of photography's function as defined in the fifties, and further, that the character of this divergence can be useful in the critical analysis of the continued evolution of American photography during the past two decades.

It seems to this viewer that the difference between White and Frank relates to the difference between the goal of self-expression and the goal of exploration. It can be argued that the alternative is illusory, that ultimately all art is concerned with self-expression. If so, the illusion of this alternative is no less important, and its character perhaps defines the difference between the romantic and the realist visions of artistic possibility.

The distinction may be expressed in terms of alternative views of the artistic function of the exterior world. The romantic view is that the meanings of the world are dependent on our own understandings. The field mouse, the skylark, the sky itself, do not earn their meanings out of their own evolutionary history, but are meaningful in terms of the anthropocentric metaphors that we assign to them. It is the realist view that the world exists independent of human atten-

ETIENNE JULES MAREY. Serial photograph showing acceleration of falling ball. c. 1887. Courtesy of André Jammes

tion, that it contains discoverable patterns of intrinsic meaning, and that by discerning these patterns, and forming models or symbols of them with the materials of his art, the artist is joined to a larger intelligence.

Because no other word seems better, *realist* is used here to support a somewhat broader meaning than it is usually asked to bear. In discourse on the visual arts, the term is generally used to denote the artist's acceptance of the surface appearance of things. The word is used here to stand for a more generous and inclusive acceptance of fact, objective structure, and the logic of process and system. Pictures made from such a posture do not always describe the surface appearance of things. It is useful to remember that the nineteenth-century experiments of Muybridge and Marey—profoundly realist in their motive—describe "appearances" which in fact only appear in the pictures themselves.

Similarly, the word *romantic* is used here not to suggest a connection with the aspect of historic styles, either in photography or in painting, but as a term that suggests the central and indispensable presence in the picture of its maker, whose sensibility is the photograph's ultimate subject, and the standard against which its success is measured.

It must be emphasized that the distinction proposed here, between realist and romantic (or expressionist) modes of artistic response, is not intended as a method of dividing recent photography into two discrete and unrelated bodies. On the contrary, the model suggested here is that of a continuous axis, the two poles of which might be described by the terms proposed above. No photographer's work could embody with perfect purity either of the two divergent motives; it is the nature of his problem to find a personally satisfactory resolution of the contesting claims of recalcitrant facts and the will to form. Certainly it would be a disservice to Minor White and Robert Frank to suggest that their work is encompassed by, or the embodiment of, an abstract analytical device. Their work makes clear that such a claim would be puerile. A selection of White's work could doubtless be made that would suggest an almost selfless fidelity to topographic documentation, and a strong romantic strain in Frank's work, still evident even in *The Americans,* inflects and modulates the basic aesthetic strategy of the work, which presents the photographer as a disinterested chance witness. Nevertheless, the basic thrust of the two men's work describes a dichotomy of feeling that has shaped the character of subsequent American photography, and that may serve as a framework for its critical consideration.

To understand better the influence of *Aperture* and *The Americans,* it may be useful to review their effect twenty years ago. It would be difficult for a photographer who is not yet forty to understand how radical Frank's book was when it first appeared, but some sense of the shock it caused, among those relative few who saw it, can be inferred from its reviews. Bruce Downes, editor of *Popular Photography,* hated the book, but recognized its force and published seven short reviews of it, including his own, under the general title "An Offbeat View of the U.S.A."[15] Of the seven opinions, only that of the late Mike Kinzer was basically sympathetic. The others described the work as disclosing "a warped objectivity," as constituting "an attack on the United States," as "the images of . . . a joyless man who hates the country of his adoption," as a vision the purity of which had been "marred by spite, bitterness, and narrow prejudice," as "a sad poem for sick people." It is a tribute to Downes that he recognized that the book was not just another comfortable collection of merely handsome or merely horrifying pictures; among the more intellectually ambitious journals, it is difficult to find mention of the book's publication.

The Americans in fact includes no photographs of lynchings, police

brutality, overt crime, or licentious sin; it shows no intimate views of dire poverty, lewd behavior, or official corruption. Such pictures, because they could be considered exotic and local, could have been more easily accepted, and even praised; Frank's pictures showed what was everywhere visible, and seldom noticed.

Tod Papageorge has pointed out that Frank's book, from an iconographic viewpoint, closely parallels Walker Evans's masterpiece *American Photographs,* published two decades earlier.[16] Although Evans's work could not be said to be the favorite fare of the photo magazines, it was never attacked in those journals with the passion that Frank's book elicited. It is significant that the angriest responses to *The Americans* came from photographers and photography specialists, many of them people of considerable sophistication in the field. It was they who recognized how profound a challenge Frank's work was to the standards of photographic style — photographic *rhetoric* — that were in large part shared even by photographers of very different philosophical postures. These standards called for a precise and unambiguous description of surface, volume, and space, and for a clearly resolved graphic structure; it was in these qualities that the seductiveness, the physical beauty, of photography lay. Frank's clear disregard for these qualities made his work seem *pharisaical,* lacking in sensitivity to, or affection for, the medium. In addition, American standards of photographic excellence required that the picture state clearly and simply what its subject was. The subject of Frank's later pictures seemed tentative, ambivalent, relative, centrifugal; the photographer's viewpoint and the disposition of the frame seemed consistently precarious and careless — lacking in care.

It was in other words not the nominal subject matter of Frank's work that shocked the photography audience but the pictures themselves, the true content of which cannot be described in terms of iconography, since it also concerns a new method of photographic description, designed to respond to experience that is kaleidoscopic, fragmentary, intuitive, and elliptical.

Aperture was not received with comparable invective. The magazine was of course not restricted to one photographer's work, and during the first year or two it was not conspicuously dominated by a single viewpoint. The pictures that it published were not in formal terms offensive to the sensibilities of those who understood the classic traditions of American photography. As the specific character of the magazine gradually became firmly established, it was not so much the aspect but the content of the pictures that seemed to some viewers slightly strange, secret, recherché. Gradually the radical nature of *Aperture's* perspective was spelled out. At bottom, Minor White was not interested in what photographs described, but in what they might connote.

In the twentieth issue of *Aperture,* Minor White and Walter Chappell published a tentative "outline for the experiencing of photographs."[17] The article stated that there are four kinds of photographs: documentary, pictorial, informational, and the *equivalent.* It was also stated that "no normal educated adult will find any difficulty with any of the pictures in the first three groups," but that the equivalent was a more complicated matter: Alfred Stieglitz said that it was a photograph that stood for "a feeling he had about something other than the subject of the photograph." In addition, the article continued, an *equivalent* must evoke "a very special emotion . . . a heightened emotion such as the East Indian would say 'takes one heavenward' or Bernard Berenson would say is 'life enhancing.'" This would seem not only a very demanding but a remarkably specific requirement, but White and Chappell seemed to relax these standards drastically later in the article by saying that "one of the safer identifying marks of the *equivalent* is a feeling that for unstatable reasons some picture is decidedly significant to you."

Reduced to its essentials, this definition of what White regarded as the highest function to which photography could aspire doubtless seems more jejune than it did in the longer and more discursive original article. In any case, the theory is outlined here not to mock it but to emphasize its fundamentally romantic, anti-intellectual, and profoundly self-centered character.

It would be gratuitous and evasive to judge White's contribution on the basis of the logic of his philosophical writings. The force of his work and thought was based on the recognition and acceptance of a simple and indisputable fact: some photographs are better than others, for reasons that we do not understand. Six photographs made in sequence may describe the same nominal subject matter; one of these may seem perfect to the photographer and his peers, and the other five lumpen and dead. The shared understanding on which this consensus is based defines the current potential of the tradition, and is, finally, intuitive and wordless.

The distinction between the truly good picture and the five ordinary ones may describe the goal of all ambitious photographers, but the goal can be pursued by a variety of strategies. Minor White attacked the goal of high eloquence frontally, and was unconcerned with—almost oblivious to—the homelier but instructive virtues that might be possessed by photographs that had not achieved a perfect state of grace. By staring so fixedly at the absolute, White risked grandiloquence, and allowed himself to become inattentive to those varieties of subject matter that had not proved capable of yielding photographs of high intensity.

The alternative view would consider the special excellence of the sixth picture to be not so much a goal as a reward, earned by the knowledge acquired in making the other five as attentively and intelligently as possible, for the sake of serving and clarifying one's understanding of a potential subject, whether or not it held out prom-ise of high success. The advantage of this alternative view is that it encourages the exploration of new subject matter, where frequent, clear failure is certain.

It was stated early in this essay that American photography of the past quarter century has pursued progressively personal concerns. In light of the two divergent concepts of photography outlined above, the word *personal* will be understood to have two distinct meanings. The pictures in the first half of this book suggest a definition of the word that leans toward autobiography, or autoanalysis; those of the second half reveal concerns that are personal in the sense that they are not popular. These concerns may be unfamiliar, eccentric, esoteric, artistically arcane, stubbornly subtle, or refined to the point of aridity, and for any of these reasons we might call them personal. Nevertheless, these pictures might also be called disinterested or objective, in the sense that they describe issues that one might attempt to define without reference to the photographer's presence. Such pictures explore the ways in which photography can translate the exterior world into pictures, which is essentially not a personal but a formal issue.

The critical framework suggested here is different from that which has underlain most efforts to rationalize the central arguments of recent American photography. Such efforts have, for the most part, considered these arguments to revolve around the distinction between "straight" photography, in which the fundamental character of the picture is defined within the camera during the moment of exposure, and "synthetic" (or manipulated) photography, in which the camera image is radically revised by darkroom manipulation, multiple printing, collage, added color, drawing, and other similarly frank and autographic modifications.

The distinction between straight and synthetic photography is a real and valid one, which defines two contrasting and perhaps antithetical concepts of aesthetic coherence. Although real, however, the distinction is of little utility as a tool for analysis. Since the distinction is based on the principle of mutual exclusivity (straight or not straight), it can serve only to divide the whole of photography into two parts. Although each part will contain a startling variety of work, their differences cannot be illuminated by the critical principle, which has exhausted itself by dividing the subject in two.

The division of photography into straight and synthetic halves has the further disadvantage of suggesting an a priori balance, or equity, between the two. In fact, few would argue that the achievements or influence of synthetic photography could be considered comparable to those of the much larger and broader body of work that we would call straight photography. To classify photographs in this manner is a little like dividing the human race into Irish and Others, an analytical method that would surely seem tendentious to the Others.

The inadequacy of the straight/synthetic dichotomy as a critical tool is demonstrated by the fact that the two photographers proposed above as exemplifying opposite photographic positions—White and Frank—were in fact both steadfastly straight photographers.

How then, in terms of the analytical structure suggested here, should synthetic (manipulated) photography be approached? It seems to this viewer that such work also concerns itself basically either with self-expression or analysis—in the first instance favoring a surrealist mode of romanticism, and in the second a structuralist approach to realism. Jerry N. Uelsmann, whose work and teaching have been conspicuously instrumental in reviving acceptance of the most extravagant manipulation of the direct camera image, makes pictures which, in their ultimate content, seem closely akin to those of Minor White. Less obviously, the work of Robert Heinecken also seems to

speak a related tongue, although with a somewhat harsher and less poetical accent. The synthetic work of Ray K. Metzker, on the other hand, or Tetsu Okuhara, seems in contrast inevitable and impersonal—driven into being not by force or will but by the operation of an elegant principle.

On the most superficial level, photographs reflecting the two attitudes discussed here will tend to exhibit several simple physical differences. On average, the pictures reproduced in the second half of this book should prove to be of a lighter general tonality than those in the first half, since the photographers who made them are more concerned with description than suggestion. They want to explain more (even at the risk of tedium), rather than dramatize less (at the risk of bombast). A single-minded concern for formal coherence, unchallenged by the wish to describe a subject, can also produce darker prints; perfect coherence can be most easily achieved by making the picture all black.

Similarly, it should prove on analysis that the pictures in the first half of this book were made from a closer vantage point or with a lens of a narrower angle of view, either of which tactic will mean that the photographer need organize less information, and can more easily achieve an abstract simplicity in the picture's design and content.

On a less mechanical level, one should expect that the two halves of the book will show different tendencies in their choice of subject matter: the first half should favor the virgin landscape, pure geometry, unidentifiable nudes, and social abstractions such as the Poor, or the Young—all subjects that strongly suggest universal platonic verities. The pictures in the second half of the book are more likely to deal with matter that is specific to a particular place or time.

These suppositions suggest a question that might usefully be asked

of a photograph: to what degree can it be dated by internal evidence? Again, Minor White and Robert Frank provide an interesting contrast. In Frank's case, the evidence of clothes, automobiles, architecture, jukeboxes, and advertisements generally identify the decade in which the picture was made. Most of White's work could not—on an iconographic basis—be attributed to the twentieth century.

As one approaches the present, it becomes progressively more difficult, and chancier, to identify with confidence those figures who have significantly revised our understanding of photography's potential. It would in fact be a philosophical error to assume that such figures must exist. A given generation of artists is not obligated to revise its premises radically, merely because some previous generations did so. It may be the function of that generation to see to the efflorescence of ideas that were defined at an earlier time. Nevertheless, it seems to this viewer that the generation represented here has defined new lines of experiment that are likely to remain persuasive for some years to come:

In the early sixties the photographer who seemed most likely to become an authentic and original successor to Minor White was Paul Caponigro. His pictures, which were constructed from materials very similar to those of his teacher, were visually more confident and muscular, and seemed less dependent on philosophical explication. In the years since, however, Caponigro's work has moved toward a more distanced and objective perspective. Although his latter work still takes little cognizance of twentieth-century subject matter, his pictures have become increasingly involved with the description of an extensive and measurable world. These photographs lie closer to the center of the axis that this essay proposes.

Jerry N. Uelsmann's fanciful, intricate, and technically brilliant montages have been broadly influential, but not widely followed. His pictures persuaded half the photography students of the sixties that manipulated photographs could be both philosophically acceptable and aesthetically rewarding, but few of those students adopted Uelsmann's fey, Edwardian surrealism, or his very demanding technical system.

In the field of manipulated photography, a broader and more elastic influence should probably be attributed to two others: Robert Rauschenberg, a painter and printmaker who has made extraordinarily inventive use of photographs and photographic techniques, and Robert Heinecken, a photographer who was originally trained as a painter and printmaker. Rauschenberg's prints absorb photographs and photographic processes with great assurance and elegance, making them almost undifferentiated elements of the expressive and formal whole. In Heinecken's pictures, a stubborn, gritty precipitate of fact survives his best efforts to dissolve it. The joyless sexuality that is central to most of his pictures retains an almost documentary authenticity, in spite of the formal ambitions of the work.

Mention should be made here of the roles of Scott Hyde and Naomi Savage, whose technical and formal experiments anticipated many of the characteristic concerns of synthetic photography during the past decade, and of Walter Chappell, who for a period in the early sixties rivaled Minor White himself as chief prophet of straight photography as a path to self-knowledge.

The mantle of leadership would seem to be more tentatively and democratically shared among those represented in the first half of this book than among those of the second half. Among the latter group, Garry Winogrand seems to this viewer to be the clearly dominant figure. To this viewer he seems, in fact, the central photographer of his generation. No other work of the period has insisted so clearly and uncompromisingly on exploring the uniquely prejudicial (intrinsic)

qualities of photographic description. Like Ansel Adams before him (but with very different subject matter, sensibility, knowledge, and machinery), Winogrand has assumed that the problem was not to make a handsome picture, but to find the way in which the real world might be transposed into something very different—a clear photograph.

Although profoundly influenced by Frank, Winogrand's work is informed by a more analytical and systematic intelligence than that of his predecessor; this intelligence has allowed Winogrand to deal successfully with experience more complex, subtle, and philosophically unresolved—more mysterious—than that described in Frank's work. The self-imposed limitation of Winogrand's art is symmetrical with its greatest strength: absolute fidelity to a photographic concept that is powerful, subtle, profound, and narrow, and dedicated solely to the exploration of stripped, essential camera vision.

Lee Friedlander's photographs are less radical and more beautiful, more open to revision and change, and filled with a sophisticated, affectionate, and playful *hommage* to his peers of the past. His work constitutes both a personal definition of the current state of the art and an annotated history of its past triumphs.

The work of the late Diane Arbus—like that of her favorite predecessors, Brassaï, Brandt, and Weegee—depended more on talent and character than on a coherent understanding of photography as a traditional discipline, and her great work was made within even more restricted technical and formal boundaries than those of her heroes. Although widely copied, her work has not provided a useful model for most of those who have attempted to emulate it.

Among those who have directed toward aesthetic ends the systematic procedures of the Victorian scientist-photographers (for example, Muybridge, Marey, Eakins), the most successful has perhaps been Ray K. Metzker. In terms of ambition, conceptual variety, intellec-

tual integrity, and visual beauty, the dozen large systematic works that he executed between 1964 and 1967 seem unsurpassed by the multitude of more recent works in a similar spirit by other artists.

The model provided by Edward Ruscha about the same time was different. Also conceptual in its nature, Ruscha's work took as its aesthetic model not the felicity of mathematics, but the comic authoritarianism of statistics. The style and sure-footed balance with which his straight-faced pseudodocuments were done endowed them in the end with their own variety of felicity, which seems entirely appropriate to their time and place: Southern California in the sixties.

One of the most interesting and suggestive developments in photography during the period considered here has been the abrupt emergence of a new and confident acceptance of the potentials of color. Among the twenty or thirty outstanding photographers working in 1960, it is likely that only two—Eliot Porter and Ernst Haas—would have said that their most important pictures were in color. For most photographers, color was something of an embarrassment—a commercial blessing and an artistic mystery. Outside of the studio, the photographer seemed to be confronted by the choice between making a picture in which the color was extraneous, and which would therefore have been better in black and white, and one which seemed a handsome colored ornament, but not in any substantive sense a photograph.

· In the late fifties and early sixties, Helen Levitt and Eliot Porter made photographs which demonstrated that color, like other aspects of pictorial form, was not necessarily a distinct issue but could be seen as an organic part of meaning. Porter's work described the aboriginal landscape and Levitt's the crowded street theater of the city, but the best work of each absorbed color into a seamless fabric of perception that was responsive to their sense of the subject.

The accomplishments of Levitt and Porter are especially remarka-

ble because both had been in their youths distinguished black-and-white photographers, in which role they taught themselves to ignore color, to see through it to an ultimate monochrome reality beyond.

A younger generation of color photographers—William Eggleston, Stephen Shore, Joel Meyerowitz, and others—have pursued parallel goals with increasing boldness, confidence, and subtlety. In Eggleston's work, especially, the distinction between the formal and descriptive meanings of color seems obliterated; color here seems as orderly, inevitable, and true-to-life as the black and white of Mathew Brady.

The intention of this analysis has not been to divide photography into two parts. On the contrary, it has been to suggest a continuum, a single axis with two poles. Many of the pictures reproduced here live close to the center of that axis, and can at the reader's pleasure be shifted mentally to the other side of the book's imaginary equator. The author, after still further reflection, will doubtless make similar revisions.

One can draw many sections through a house that will help one better comprehend the structure of the whole. It must be understood, however, that these section views are merely analytical devices, and therefore, by definition, describe less than the whole. At best, such analysis helps explain the subject at some risk to its integrity. After indulging one's curiosity by cutting into the body of the matter, one should admit that the inviolate whole is more beautiful, even if more mysterious.

The artists represented in this book are all, finally, concerned with the pursuit of beauty: that formal integrity which pays homage to the dream of meaningful life. They pursue this goal within a wide variety of rubrics, but they share in considerable measure a sense of common precedents.

The two creative motives that have been contrasted here are not discrete. Ultimately each of the pictures in this book is part of a single, complex, plastic tradition. Since the early days of that tradition, an interior debate has contested issues parallel to those illustrated here. The prejudices and inclinations expressed by the pictures in this book suggest positions that are familiar from older disputes. In terms of the best photography of a half century ago, one might say that Alfred Stieglitz is the patron of the first half of this book and Eugène Atget of the second. In either case, what artist could want a more distinguished sponsor? The distance between them is to be measured not in terms of the relative force or originality of their work, but in terms of their conceptions of what a photograph is: is it a mirror, reflecting a portrait of the artist who made it, or a window, through which one might better know the world?

JOHN SZARKOWSKI

Notes

1. In 1955 the photographer Gjon Mili made a film called *The Tall Man* (not commercially released), in which he followed *Life* photographer Alfred Eisenstaedt on an assignment for the magazine. In one scene, a meeting with editors and others involved in preparing a *Life* story, Eisenstaedt, at the periphery of the circle of taller, indoor journalists, attempts to peer around the shoulders of his theoretical collaborators to see what they are doing to his story.

2. *Life* died in 1972; *Look* in 1971; *The Saturday Evening Post,* 1969; *This Week,* 1969; *American Weekly,* 1963; *Coronet,* 1961; *Collier's,* 1957. *Holiday,* after its reorganization in 1971, ceased to be a major market for photographers.

3. "Franklin Roosevelt's Wild West," *Life,* vol. 1, no. 1 (Nov. 23, 1936).

4. One of the best of several Bourke-White stories on Russia was "Muscovites Take Up Their Guns as Nazi Horde Approaches Russian Capital," *Life,* vol. 11, no. 17 (Oct. 27, 1941).

5. "Country Doctor," *Life,* vol. 25 (Sept. 20, 1948).

6. "Spanish Village," *Life,* vol. 30 (April 9, 1951).

7. In April of 1967, after reading Mary McCarthy's recently published reports on Saigon in *Vietnam* (New York: Harcourt, Brace & World, 1967), Lee Friedlander proposed to *Esquire* that he be sent to photograph the character of that city, under the influence of the war and the massive American military and diplomatic presence. Friedlander pointed out that the traditional battlefield story was being covered, but suggested that a visual report on the life and aspect of the capital city might provide interesting new insights. *Esquire,* and subsequently several other magazines and agencies, did not find the idea interesting.

8. László Moholy-Nagy, "From Pigment to Light," *Telechor,* vol. 1, no. 2 (1936). Reprinted in *Photographers on Photography,* ed. Nathan Lyons, (Englewood Cliffs, N.J.: Prentice-Hall, 1966), pp. 72–80.

9. For a coherent summary of the period's view, see Nicholas Brown et al, *Report of the Committee on the Visual Arts at Harvard University* (Cambridge, Mass.: Harvard University Press, 1956), known as "The Brown Report."

10. C. William Horrell, *A Survey of Photographic Instruction,* 3rd ed. (Rochester, N.Y.: Eastman Kodak Co., 1968), p. 3.

11. Art Sinsabaugh, "Photography and Cinematography within the University" (unpublished paper presented to a committee of the University of Illinois, Fall 1970).

12. The first successful commercial photography gallery was the Witkin Gallery, which opened in New York in 1969. Museum interest in photography also increased substantially in the sixties. In 1965 the annual reports of The Art Institute of Chicago, Boston Museum of Fine Arts, The Metropolitan Museum of Art, New York, and the Houston Museum of Fine Arts mention a cumulative total of 148 photographs acquired during the year. Ten years later the same institutions reported 506 photographs acquired. The institutions were selected at random, because of the immediate availability of their reports.

13. *Aperture* was first published in San Francisco in 1952 by Minor White. After the first seven issues, the magazine was published in Rochester, N.Y. In 1965 Michael Hoffman became Publisher, and later Managing Editor. It is currently published in Millerton, N.Y.

 The Americans was first published in France as *Les Américains,* with a text by Alain Bosquet (Paris: Robert Delpire, 1958). The first American edition—without the Bosquet text, and with an introduction by Jack Kerouac—appeared a year later (New York: Grove Press, 1959). It was reissued in 1969 with an addendum referring to Frank's first four films (New York: Aperture, 1969).

 "The Family of Man" opened at The Museum of Modern Art, New York, in January 1955, and was subsequently circulated in three copies to forty-one exhibitors. The exhibition was conceived and directed by Edward Steichen, assisted by Wayne Miller, and designed by Paul Rudolph. The book based on the exhibition has sold over four million copies.

14. "Panoramic Show at The Museum of Modern Art," *The New York Times,* January 30, 1955.

15. Published in *Popular Photography,* May 1960, pp. 104–106. The authors of the several reviews were Les Barry, Bruce Downes, John Durniak, Arthur Goldsmith, H. M. Kinzer, Charles Reynolds, and James M. Zanutto.

16. Tod Papageorge, *Garry Winogrand: Public Relations* (New York: The Museum of Modern Art, 1977), p. 11.

17. *Aperture,* vol. 5, no. 4 (1957), pp. 156 ff.

Part I

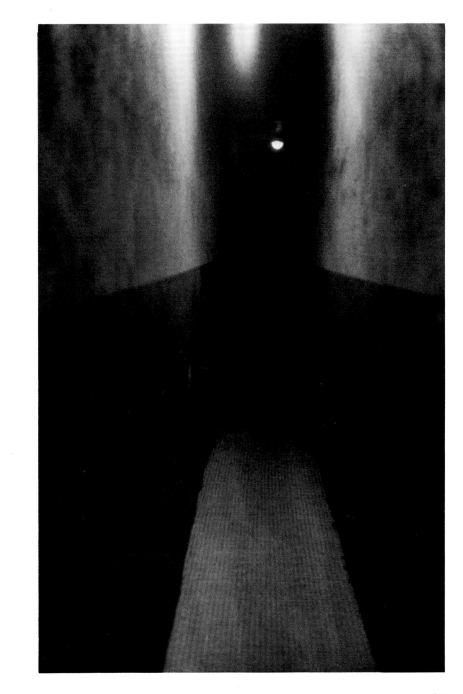

ROY DeCARAVA
Hallway. 1952
9½ x 6¼ inches
The Museum of Modern Art, New York
Gift of the photographer

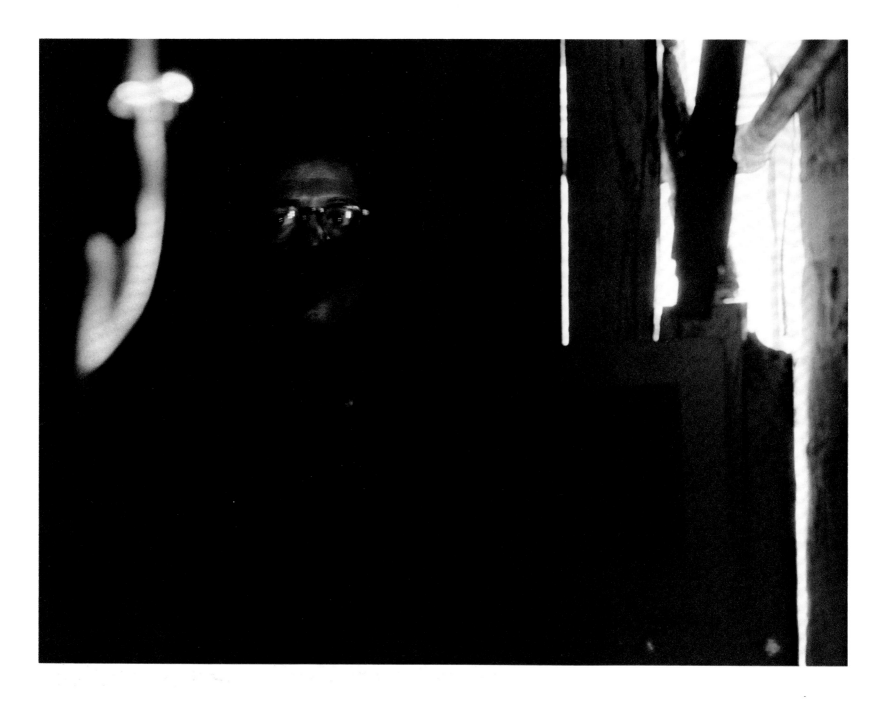

Opposite:
Roy DeCarava
Self-Portrait. 1956
10⅛ x 13¹¹/₁₆ inches
The Museum of Modern Art, New York
Purchase

Walter Chappell
Untitled. 1959
9⅛ x 7½ inches
The Museum of Modern Art, New York
Purchase

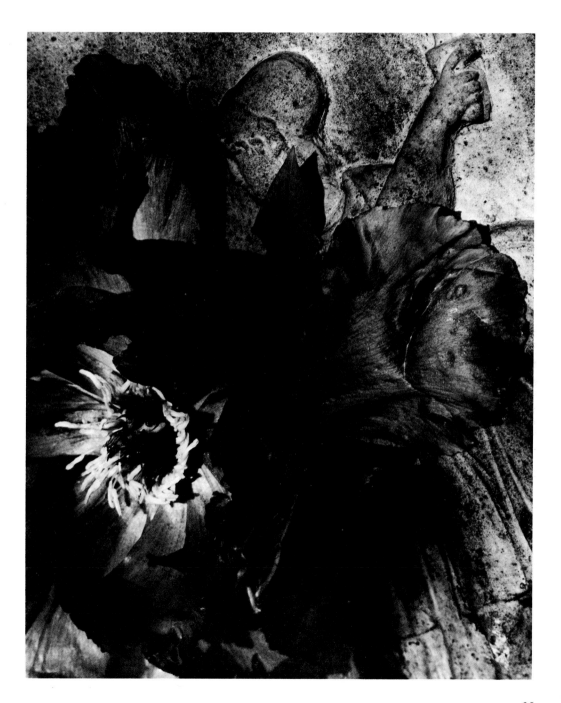

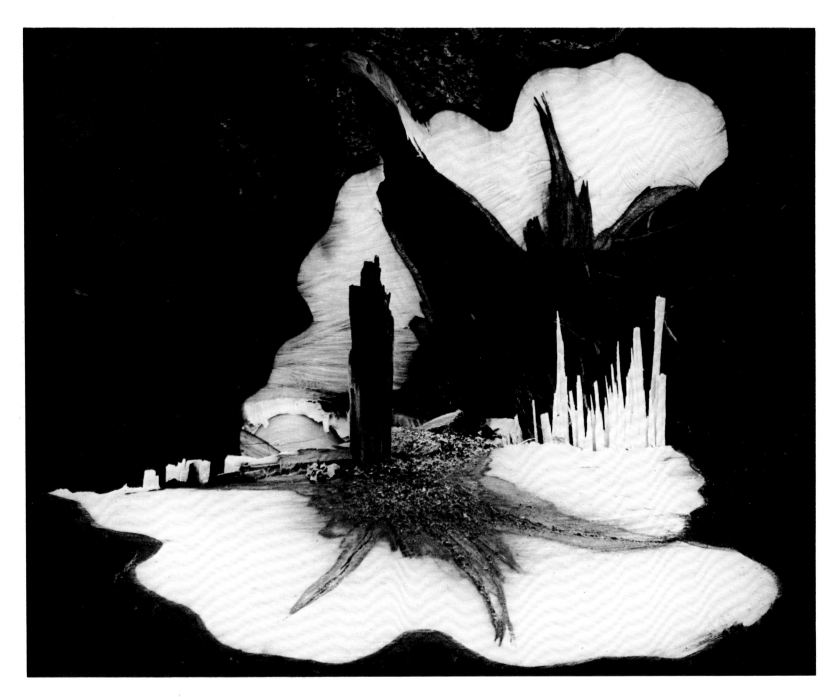

Opposite:
PAUL CAPONIGRO
Untitled. 1957
7¾ x 9¾ inches
The Museum of Modern Art, New York
Purchase

PAUL CAPONIGRO
Fungus, Ipswich, Massachusetts. 1962
13 x 10 inches
The Museum of Modern Art, New York
Purchase

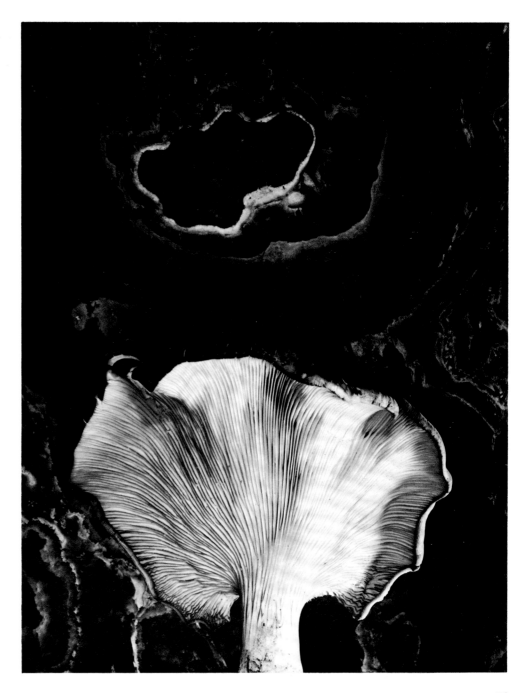

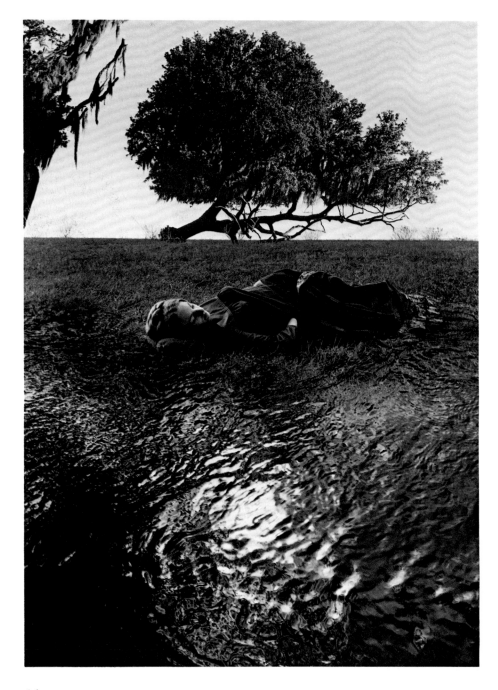

Opposite:
JERRY N. UELSMANN
Untitled. 1966
13¾ x 10¹⁄₁₆ inches
The Museum of Modern Art, New York
David H. McAlpin Fund

JERRY N. UELSMANN
Untitled. 1964
13½ x 10 inches
The Museum of Modern Art, New York
Purchase

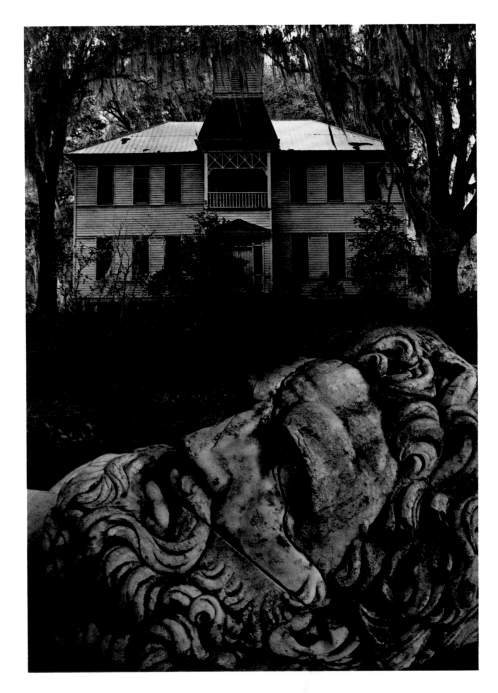

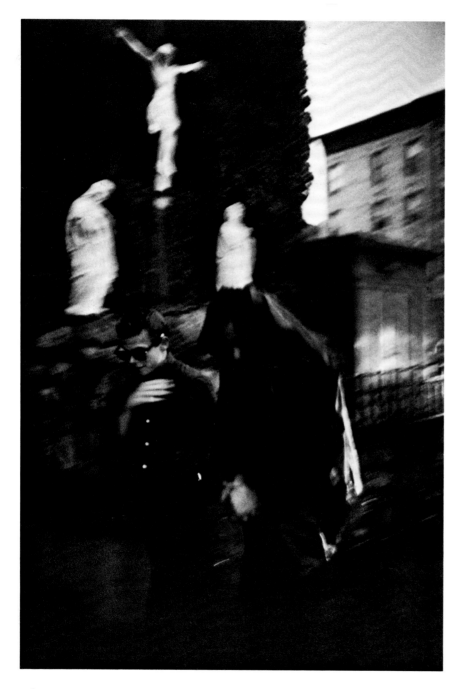

Opposite:
Bruce Davidson
Untitled (from the series "Teen-Agers"). 1959
10 x 6¾ inches
The Museum of Modern Art, New York
Purchase

George Krause
Untitled (from the series "Qui Riposa"). n.d.
6⅛ x 4⅛ inches
The Museum of Modern Art, New York
Purchase

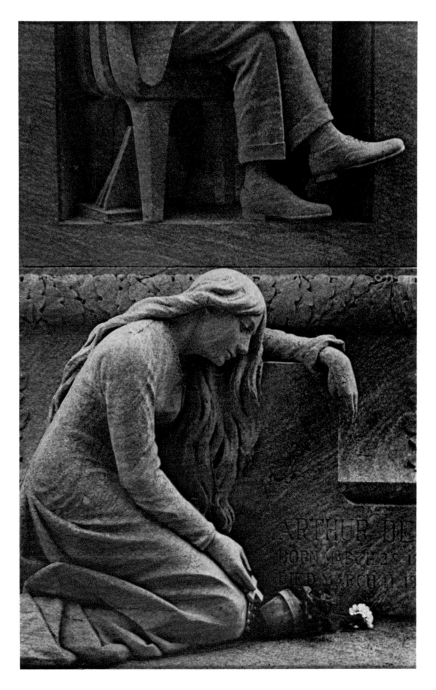

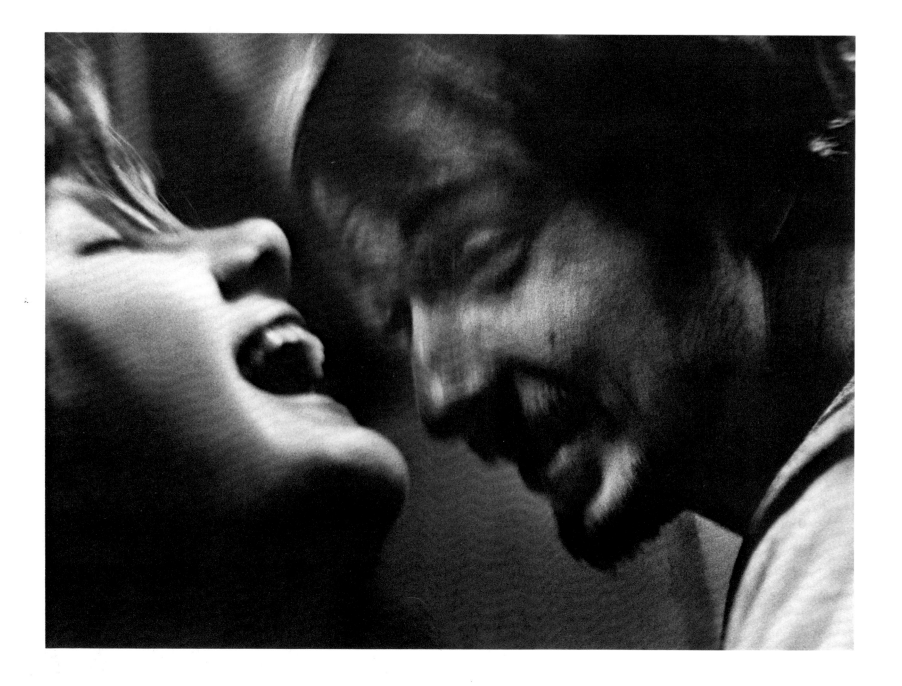

Opposite:
DAVE HEATH
*Arnie and Sheila in 7 Arts Coffee
Gallery, New York.* 1959
6¹¹/₁₆ x 9⅛ inches
The Museum of Modern Art, New York
Purchase

MAX WALDMAN
Untitled (*Marat/Sade*). 1966
11¾ x 8⅞ inches
Collection the photographer

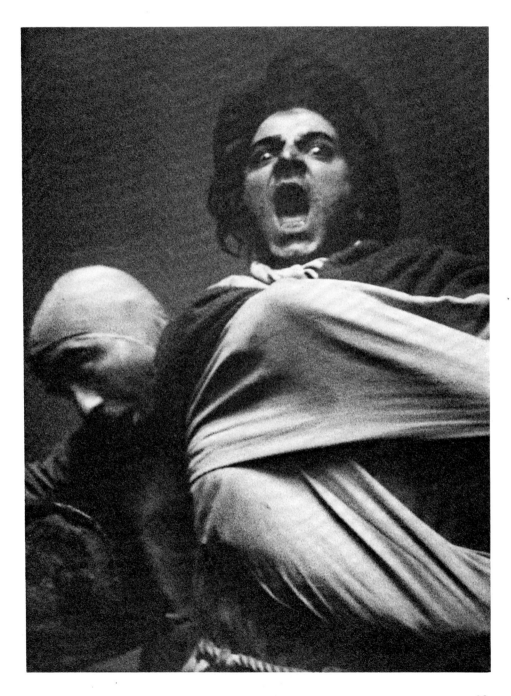

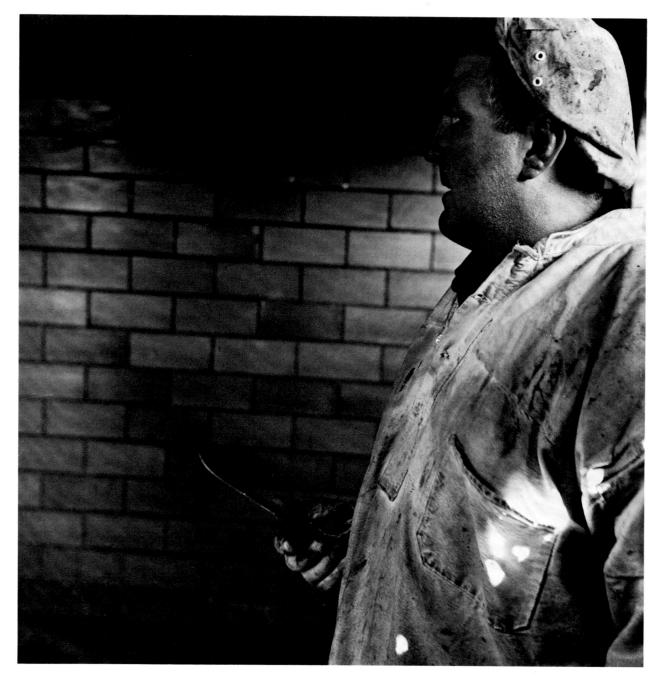

JEROME LIEBLING
Slaughter House. 1960–61.
9¾ x 9¾ inches
The Museum of Modern Art,
New York
Exchange

Opposite:
DANNY LYON
Ellis Prison, Texas. 1968
8¼ x 12¼ inches
The Museum of Modern Art,
New York
Purchase

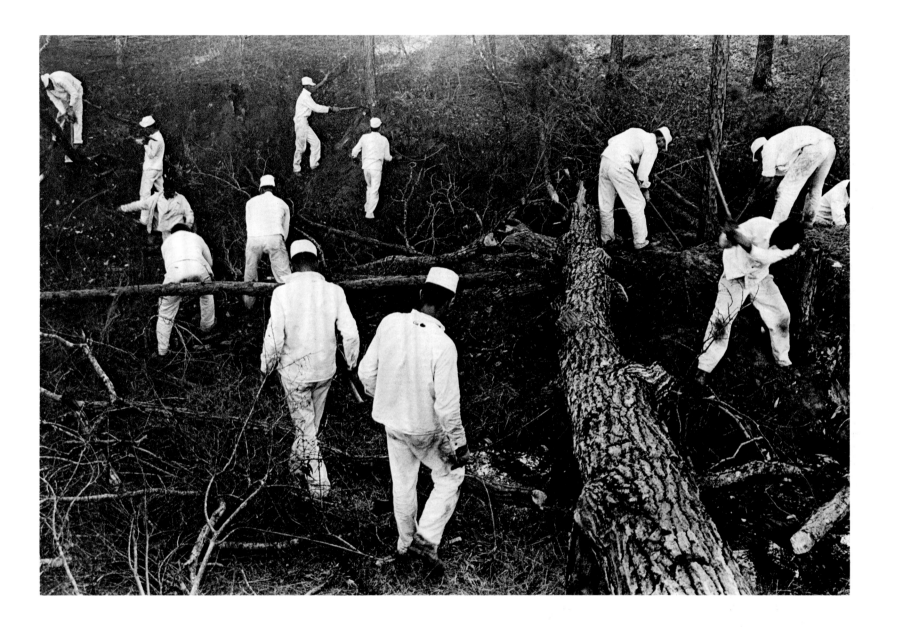

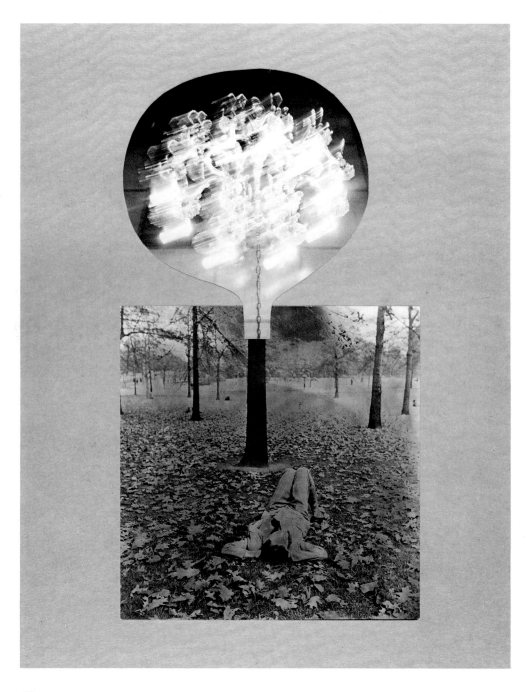

JOSEPH BELLANCA
A Special Place. 1964
17¹⁄₁₆ x 9⅝ inches
The Museum of Modern Art, New York
Gift of the photographer

Opposite:
GIANNI PENATI
Untitled. 1956 – 64.
8½ x 12¼ inches
The Museum of Modern Art, New York
Purchase

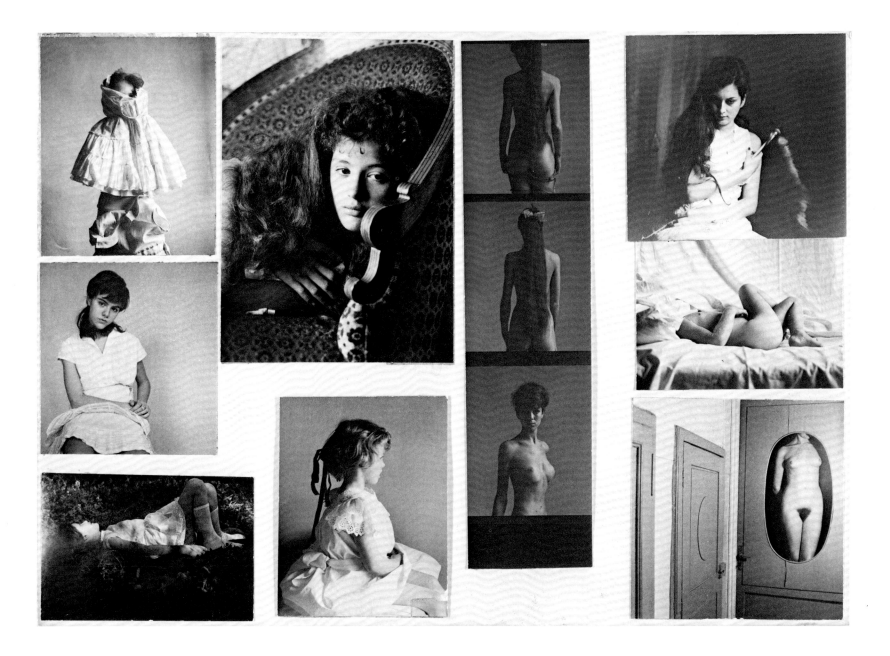

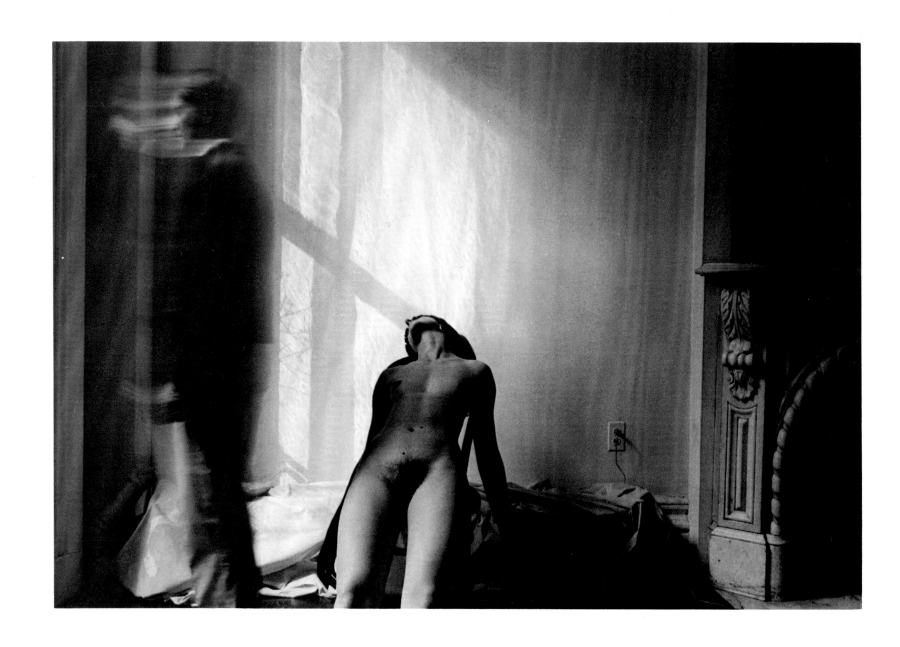

DUANE MICHALS. Untitled. 1968. 6½ x 9½ inches. The Museum of Modern Art, New York. The Parkinson Fund

44

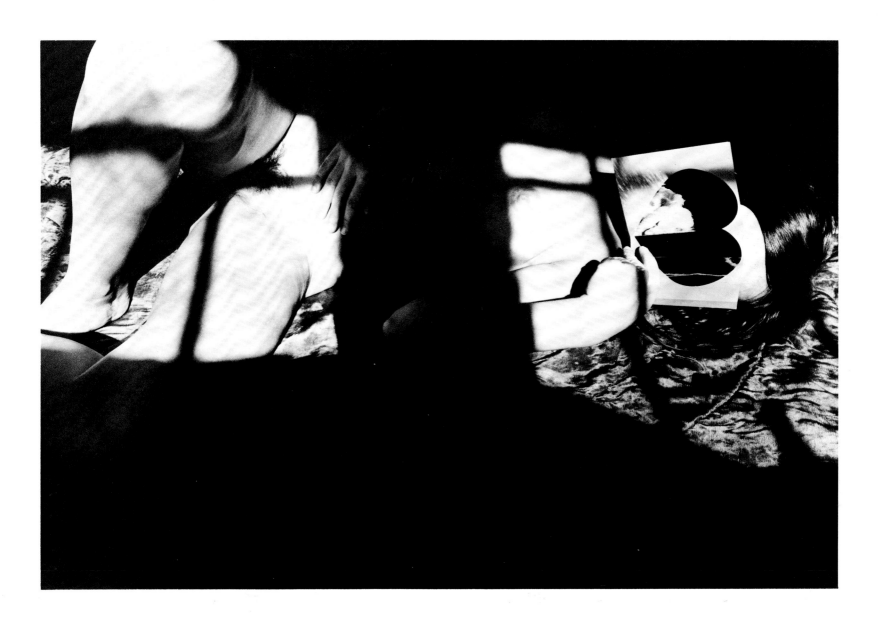

ROGER MERTIN. *Casual Heart #1*. 1969. 5¼ x 7½ inches. The Museum of Modern Art, New York. Purchase

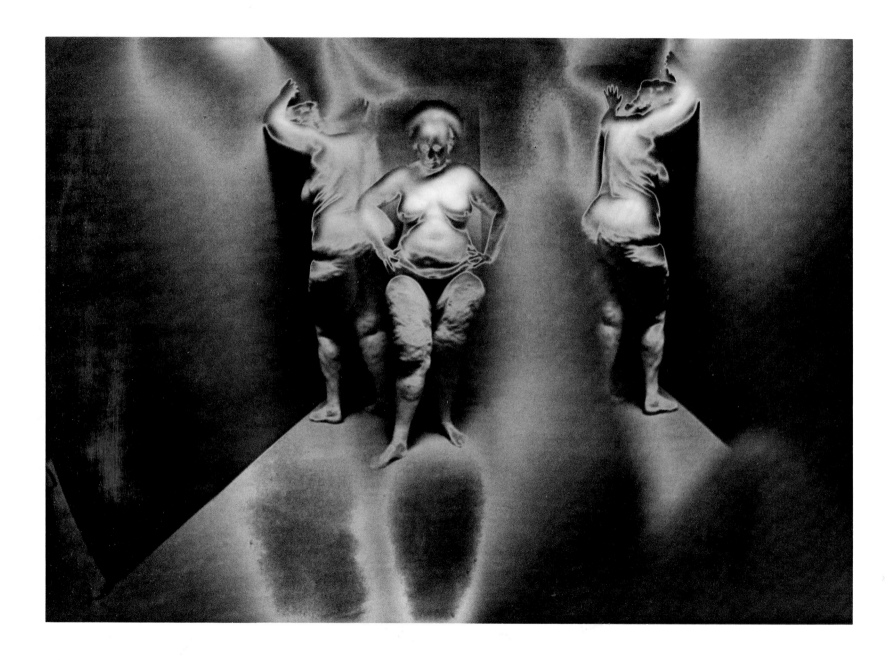

Opposite:
TODD WALKER
Untitled. 1970
Monoprint, 6^{11}/$_{16}$ x 9^{11}/$_{16}$ inches
The Museum of Modern Art,
New York
Purchase

ROBERT HEINECKEN
Refractive Hexagon. 1965
24 movable photographic
pieces on wood,
17⅞ x 17⅞ x ½ inches
Collection the photographer

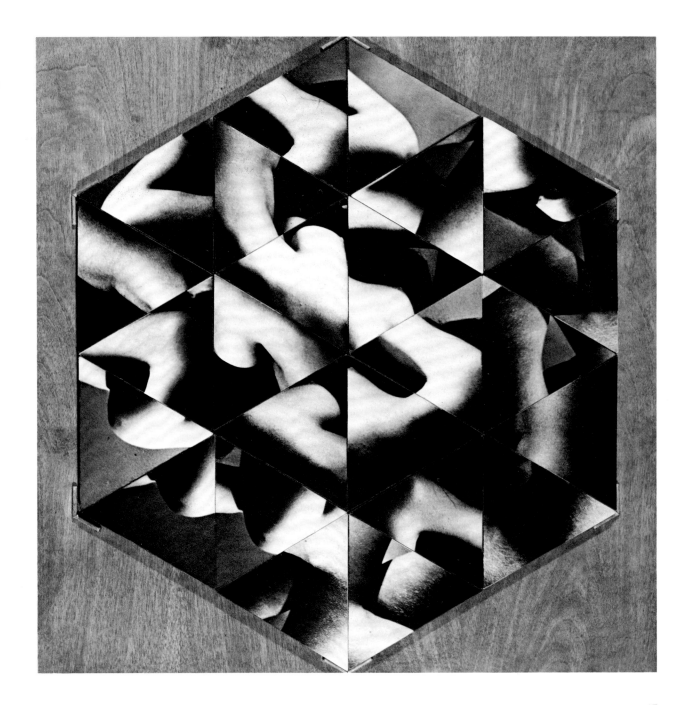

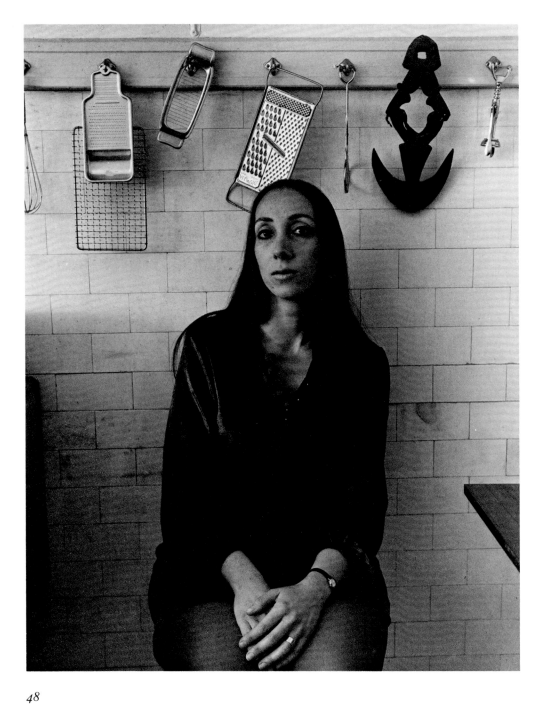

Opposite:
JUDY DATER
Joyce Goldstein in Her Kitchen. 1969
13⅜ x 10½ inches
The Museum of Modern Art, New York
Purchase

RALPH GIBSON
The Enchanted Hand. 1969
12⅛ x 8⅜ inches
The Museum of Modern Art, New York
Gift of the photographer

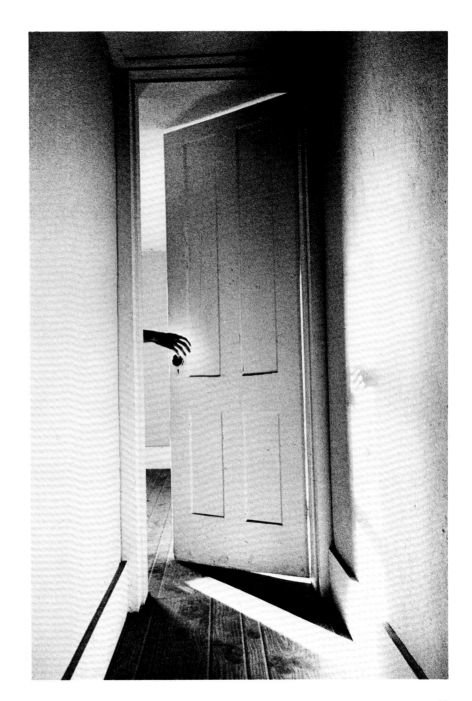

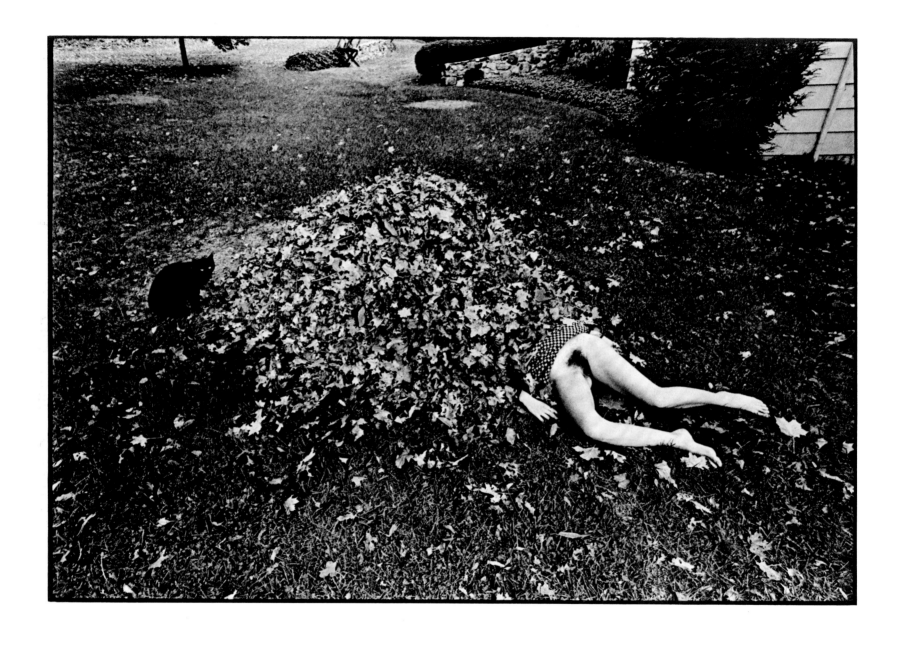

Leslie Krims. Untitled. 1970. Kodalith print, 6 x 7¼ inches. The Museum of Modern Art, New York. Purchase

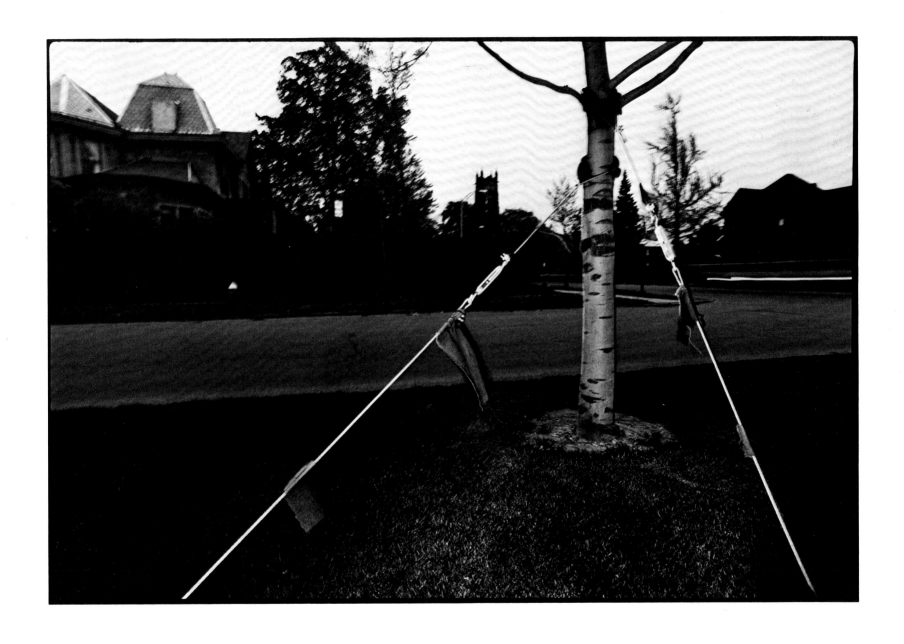

ROGER MERTIN. *Tree, Rochester, New York*. 1973. 9 x 12½ inches. The Museum of Modern Art, New York. David H. McAlpin Fund

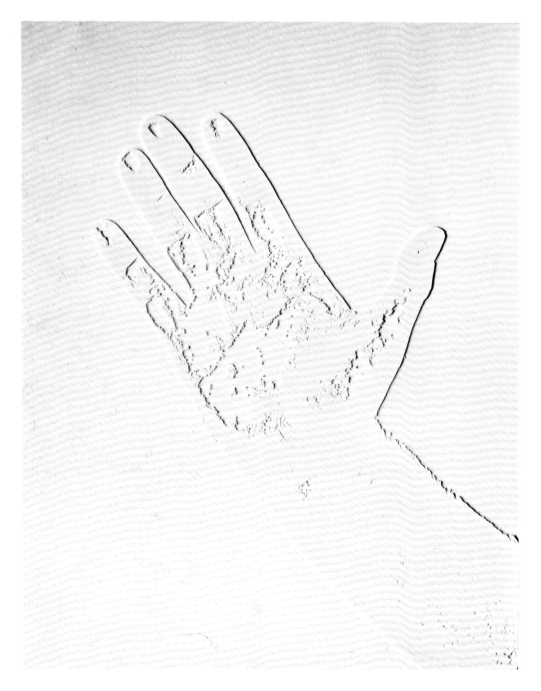

NAOMI SAVAGE
Beforehand. 1968.
Inkless intaglio, 13½ x 10⁹⁄₁₆ inches
The Museum of Modern Art, New York
Purchase

Opposite:
ANDY WARHOL
Marilyn Monroe
(from a portfolio of 10 serigraphs). 1967
36 x 36 inches
The Museum of Modern Art, New York
Gift of David Whitney

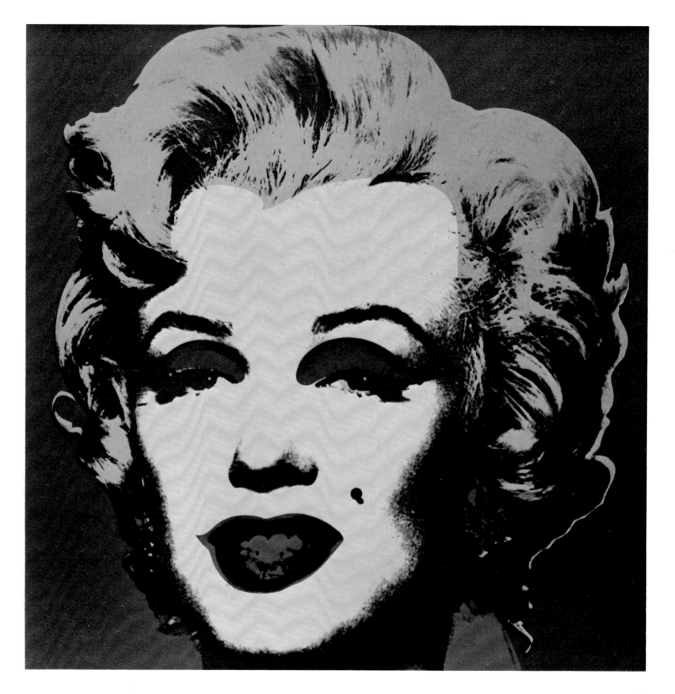

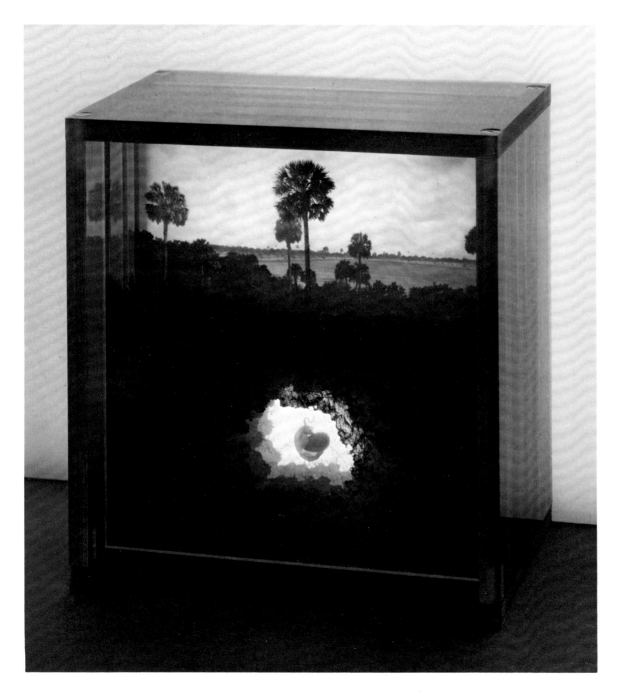

Opposite:
DOUGLAS PRINCE
Seed Chamber. 1970
Film and Plexiglas construction,
5⅜ x 5⅛ x 3⅛ inches
The Museum of Modern Art, New York
Purchase

JERRY MCMILLAN
Untitled, Torn Bag. 1968
Three-color lithograph
inside paper-bag construction,
9¾ x 5⅞ x 3⅜ inches
Collection Jackie and Manny Silverman,
Los Angeles

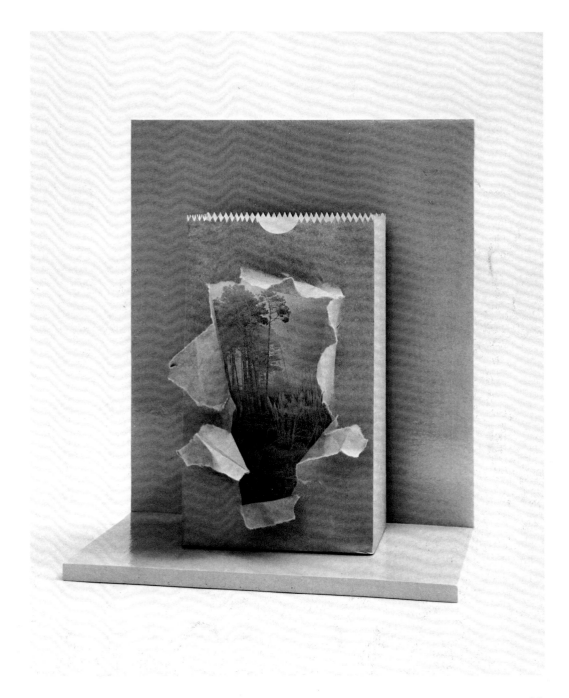

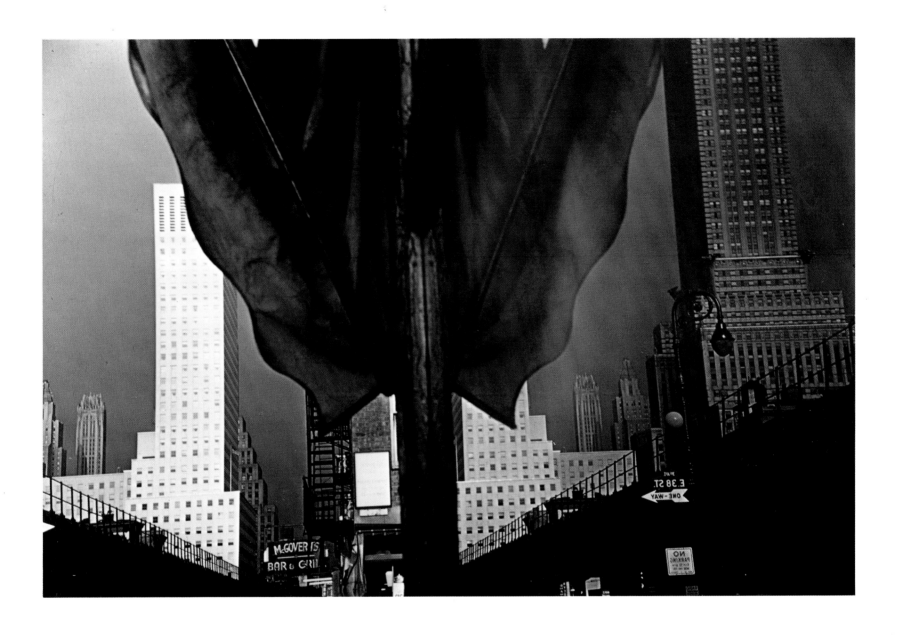

Ernst Haas. *Corner of 38th Street.* 1952. Dye transfer print, 15 x 22^{7}/$_{16}$ inches. The Museum of Modern Art, New York. Gift of Leo Pavelle

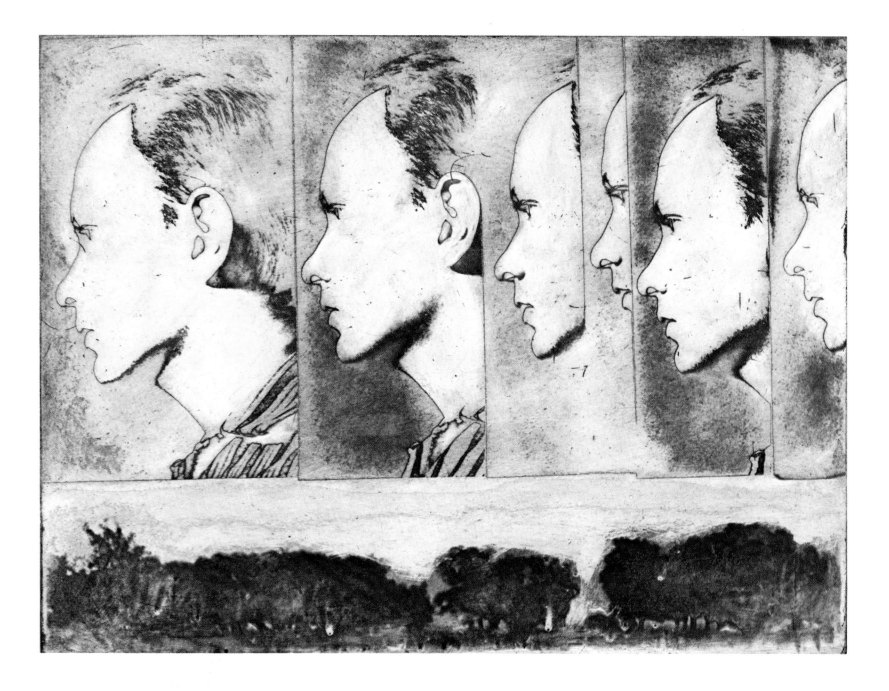

58

Opposite:
KEITH A. SMITH
Figure in Landscape. 1966
Photoetching, 9 x 12 inches
The Museum of Modern Art, New York
Purchase

ROBERT RAUSCHENBERG
Kiesler. 1966
Offset lithograph, 34 x 22 inches
The Museum of Modern Art, New York
John B. Turner Fund

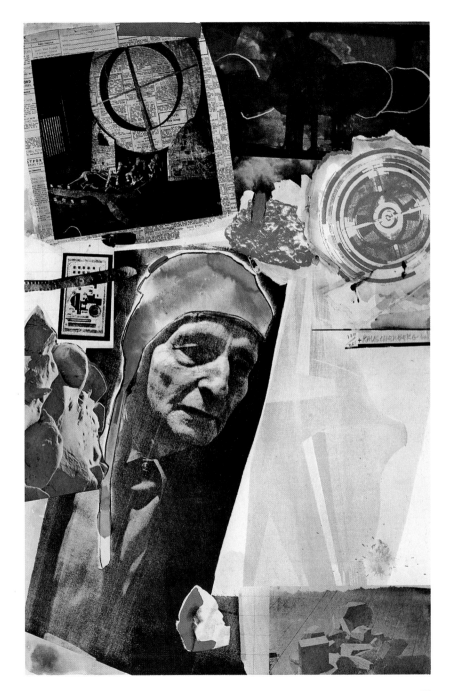

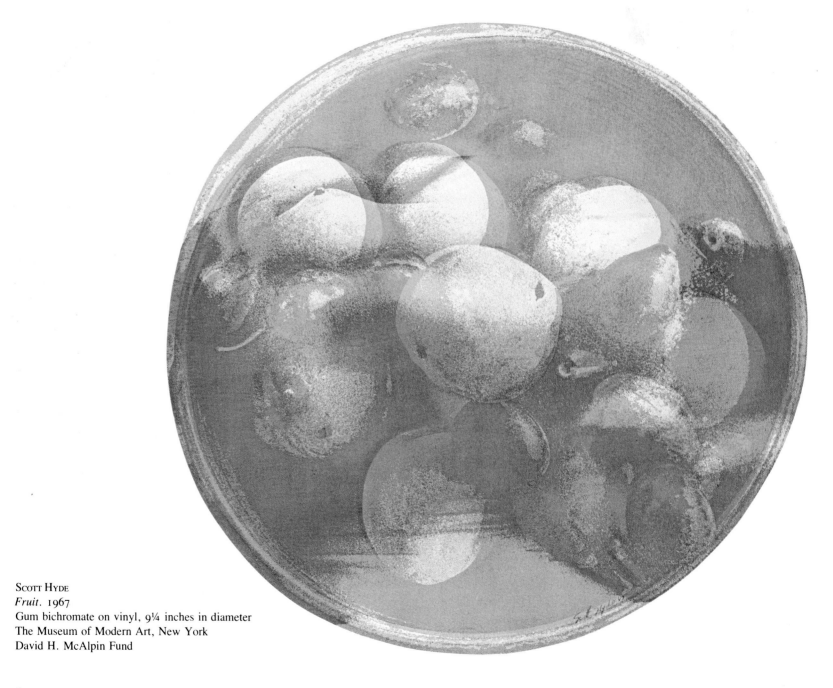

Scott Hyde
Fruit. 1967
Gum bichromate on vinyl, 9¼ inches in diameter
The Museum of Modern Art, New York
David H. McAlpin Fund

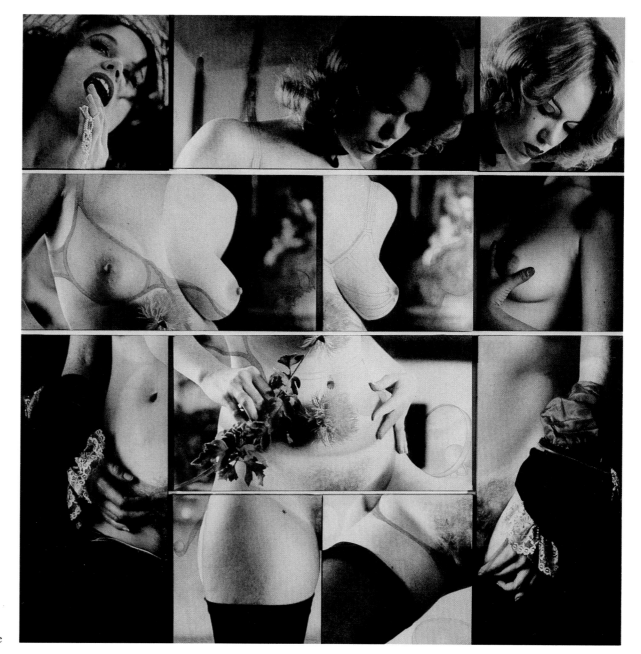

ROBERT HEINECKEN
Cliche Vary/Autoeroticism. 1974
Photographic emulsion on canvas,
pastel chalk, 40¾ x 40¾ inches
Collection William and Andrea Turnage

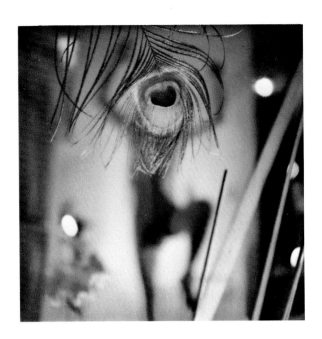

Lucas Samaras
Photo-Transformation #6469. 1976
Polaroid SX-70 print, 3 x 3 inches
The Museum of Modern Art, New York
Gift of the American Art Foundation

Opposite:
Leland Rice
Wall Site #34. 1977
Type C print, 14¼ x 17⅜ inches
The Museum of Modern Art, New York
Acquired with matching funds
from the Frank Strick Foundation
and the National Endowment
for the Arts

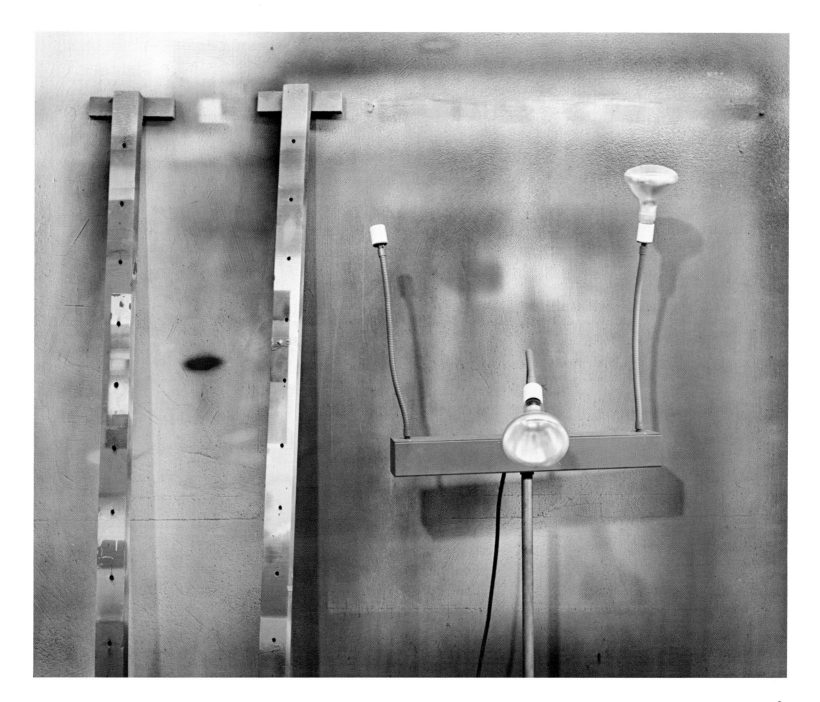

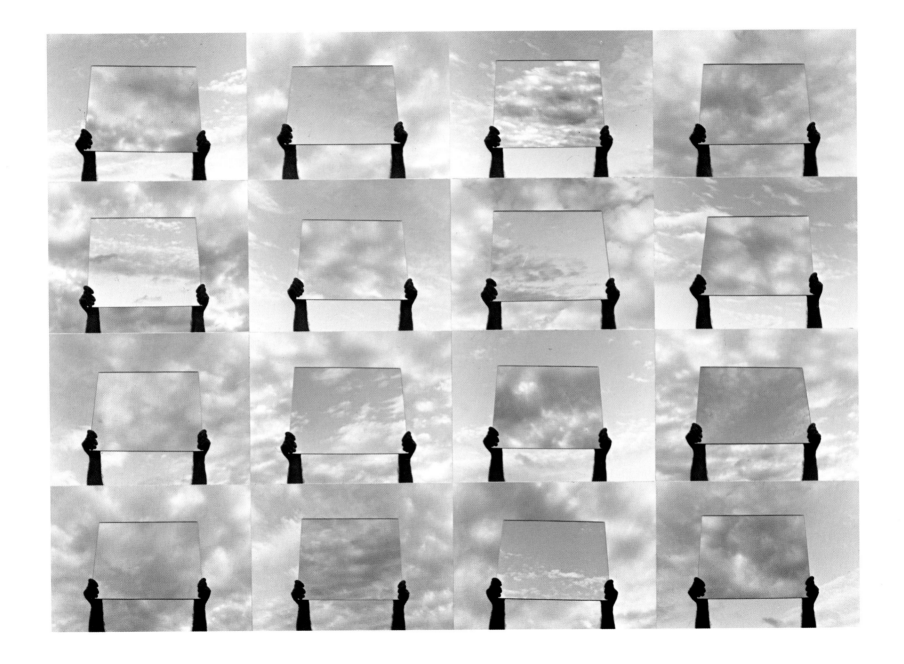

GARY BEYDLER
20 Minutes in April. 1976
Type C print, 13⅝ x 18¾ inches
The Museum of Modern Art, New York
Acquired with matching funds
from David H. McAlpin and
the National Endowment for the Arts

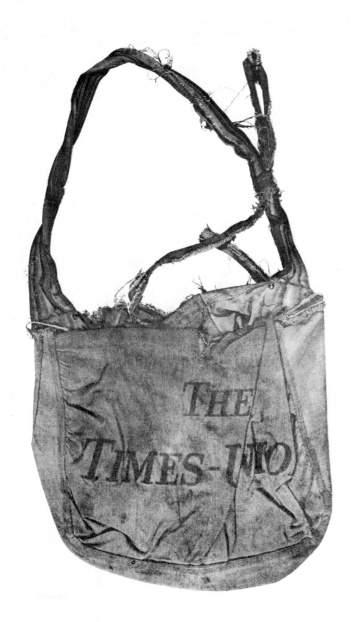

JOAN LYONS
Untitled (from *Artifacts,* a portfolio
of 10 offset lithographs). 1973
25¾ x 19 inches
The Museum of Modern Art, New York
Joseph G. Mayer Foundation

Opposite:
ROBERT RAUSCHENBERG
Unit (Buffalo). 1969
Lithograph, 18⅛ x 23¾ inches
The Museum of Modern Art, New York
Gift of the Celeste and Armand Bartos Foundation

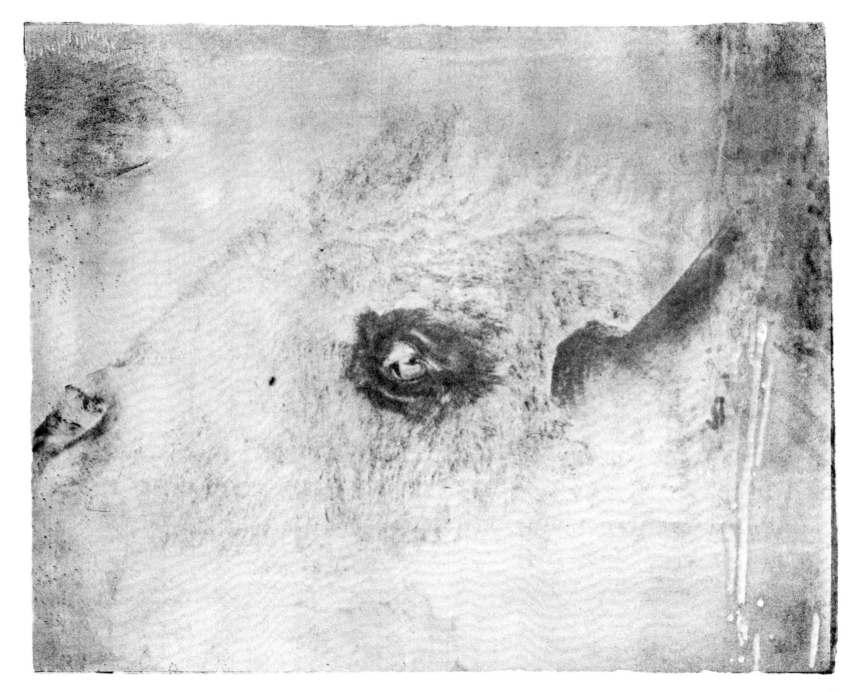

DUANE MICHALS
Chance Meeting. 1969
Series of 6 prints, each 3¼ x 4⅞ inches
The Museum of Modern Art, New York
Gift of the photographer

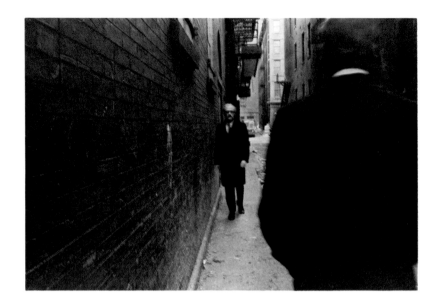

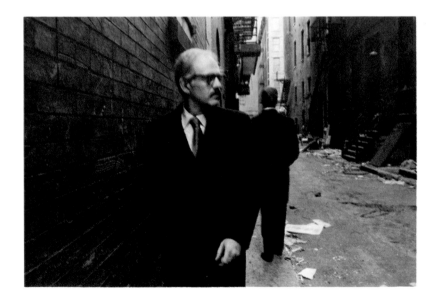

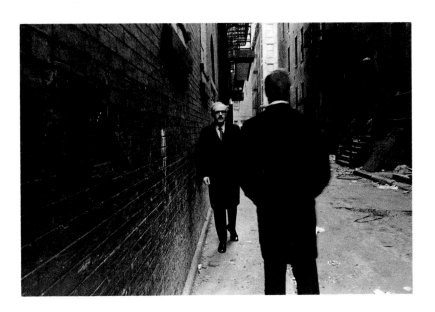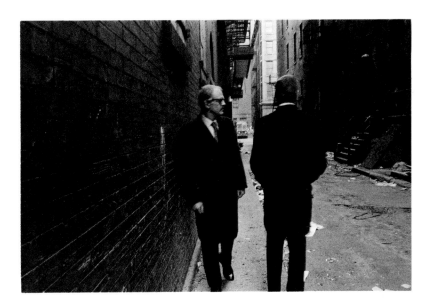
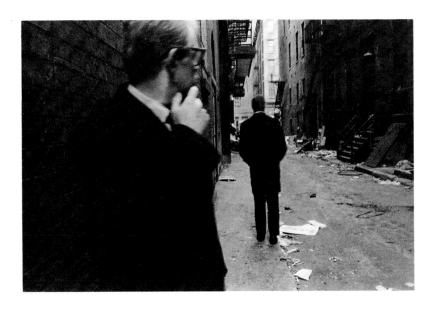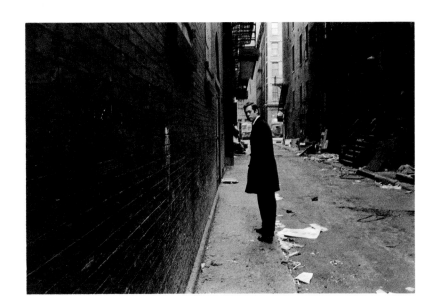

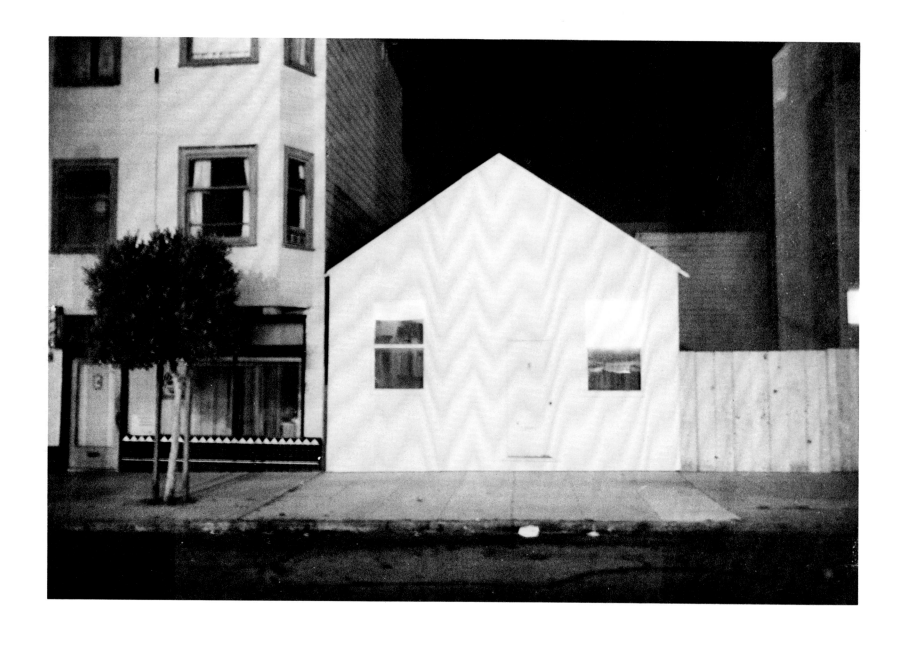

BILL ARNOLD. Untitled. c. 1970. Microfilm reader-printer machine print, 15 x 22 inches. The Museum of Modern Art, New York. Purchase

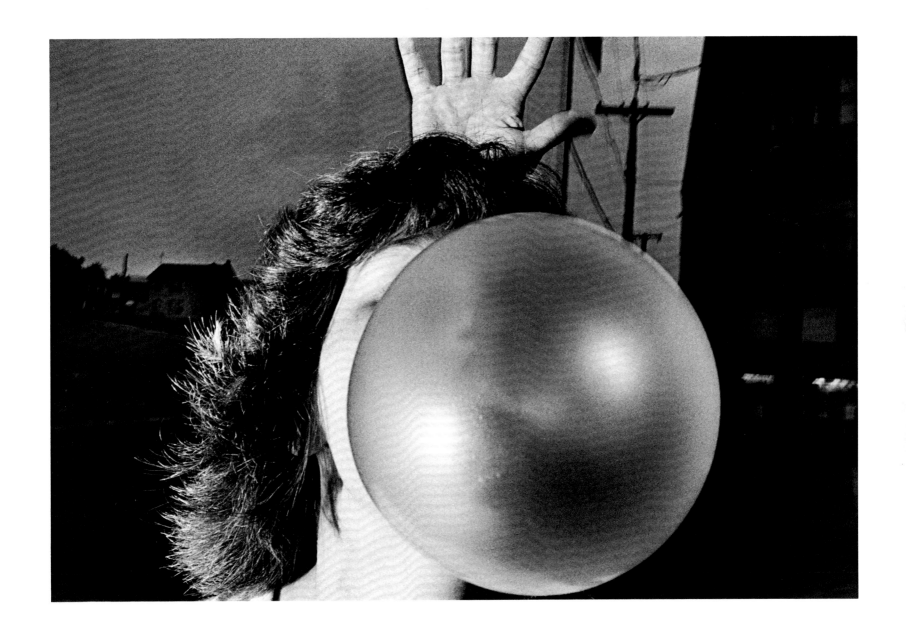

MARK COHEN. *Wilkes-Barre, Pennsylvania, June, 1975.* 11¾ x 17¾ inches. The Museum of Modern Art, New York. Gift of the photographer

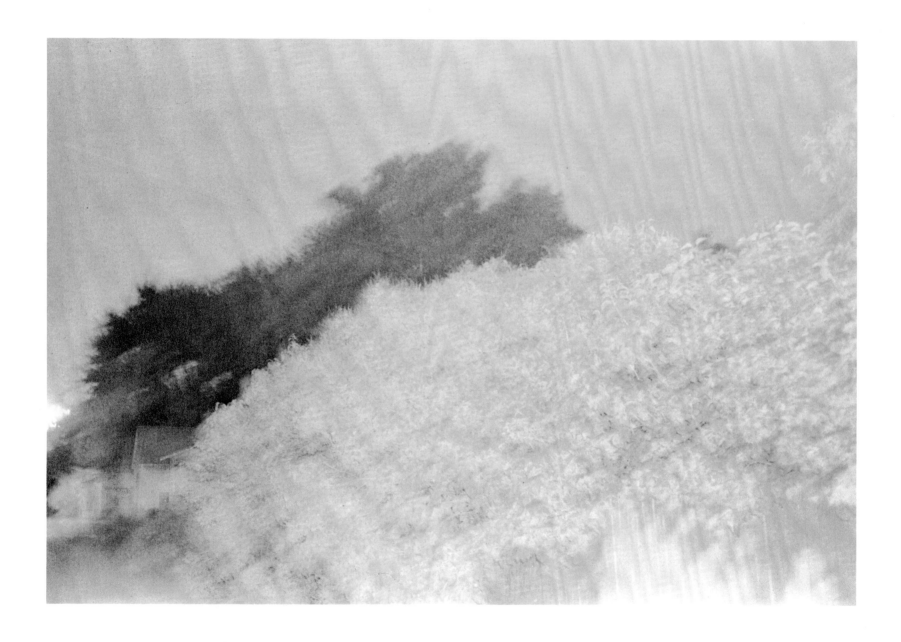

Opposite:
GARY L. HALLMAN
Minnehaha Alley. 1971
Toned mural paper, 22 x 32⅞ inches
The Museum of Modern Art, New York
Mrs. Douglas Auchincloss Fund

EMMET GOWIN
Danville, Virginia. 1973
9½ x 7½ inches
The Museum of Modern Art, New York
David H. McAlpin Fund

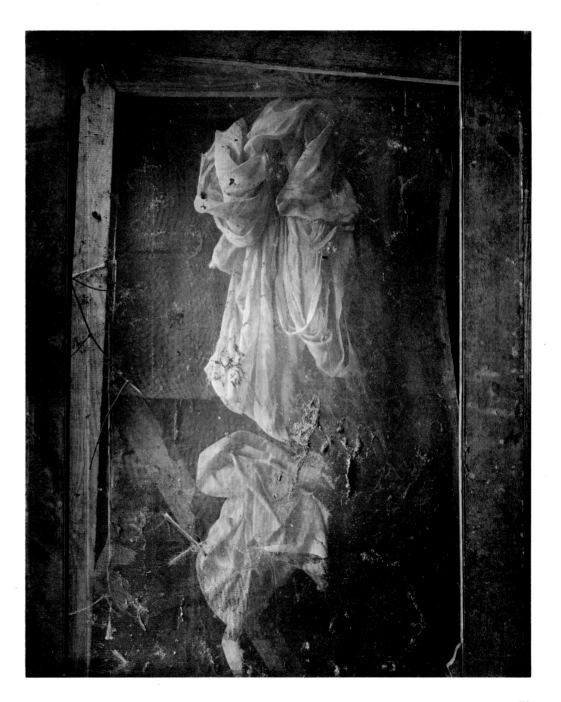

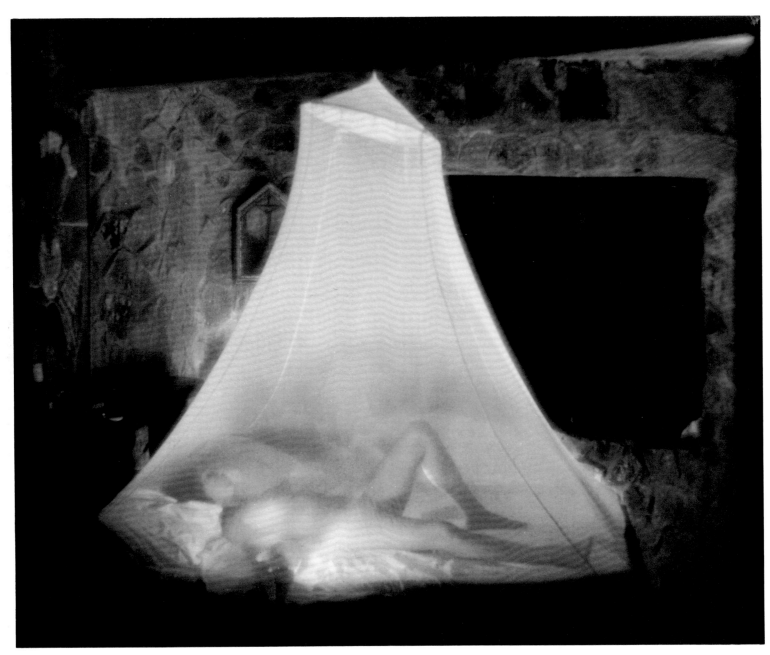

LINDA CONNOR. Untitled. 1976. 8 x 10 inches. The Museum of Modern Art, New York. John Parkinson III Fund

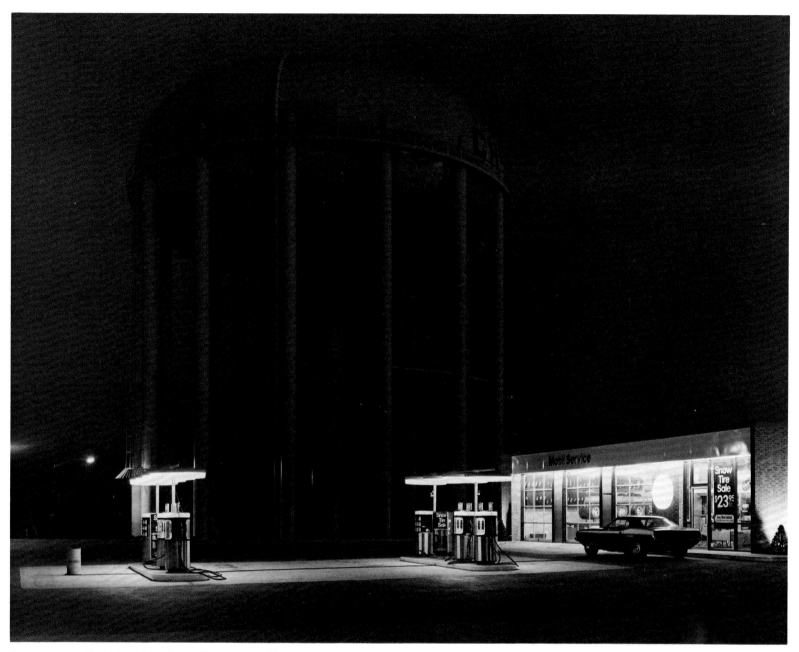

GEORGE A. TICE. *Petit's Mobil Station and Watertower, Cherry Hill, New Jersey.* 1974. 15 x 19 inches. The Museum of Modern Art, New York. Purchase

JOSEPH DANKOWSKI
Manholes
(from an album of 27 photographs). 1969–71
Each 6 x 9 inches
The Museum of Modern Art, New York
Gift of the photographer

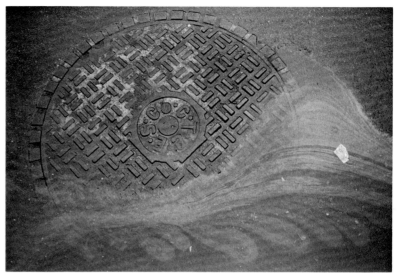
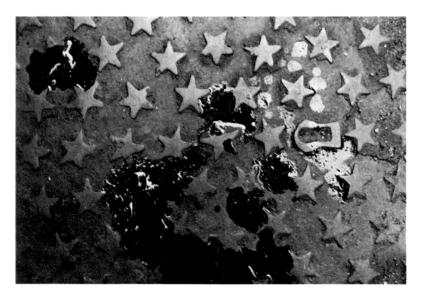
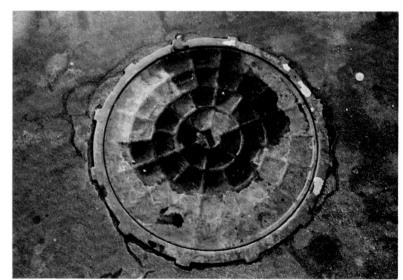

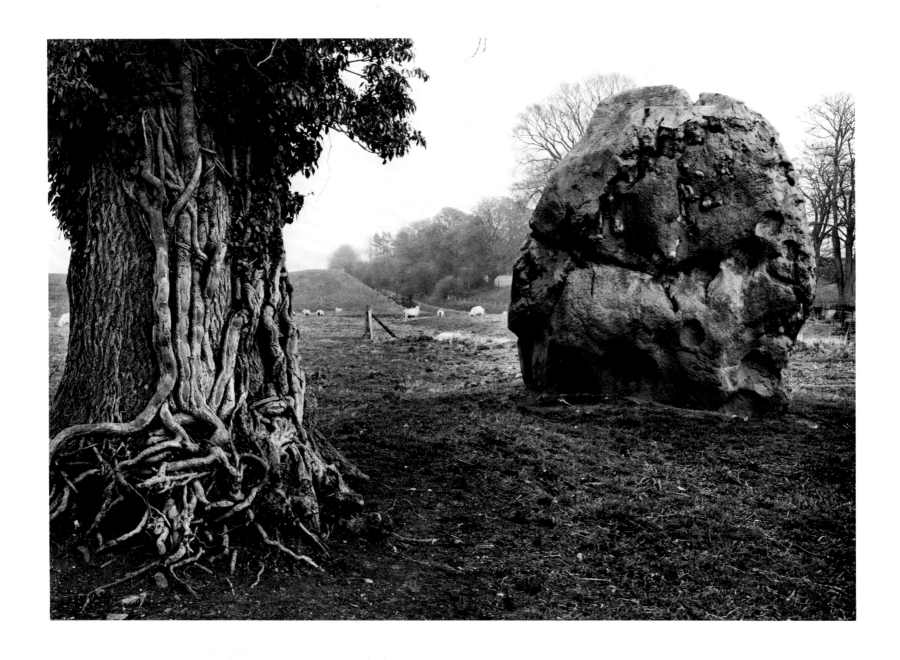

Opposite:
PAUL CAPONIGRO
Avebury Stone Circle. Avebury, Wiltshire, England. 1967
7⅜ x 10½ inches
The Museum of Modern Art, New York
Mr. and Mrs. John Spencer Fund

PAUL CAPONIGRO
Avebury Stone Circle (Detail). Avebury, Wiltshire, England. 1967
10⅜ x 7½ inches
The Museum of Modern Art, New York
Mr. and Mrs. John Spencer Fund

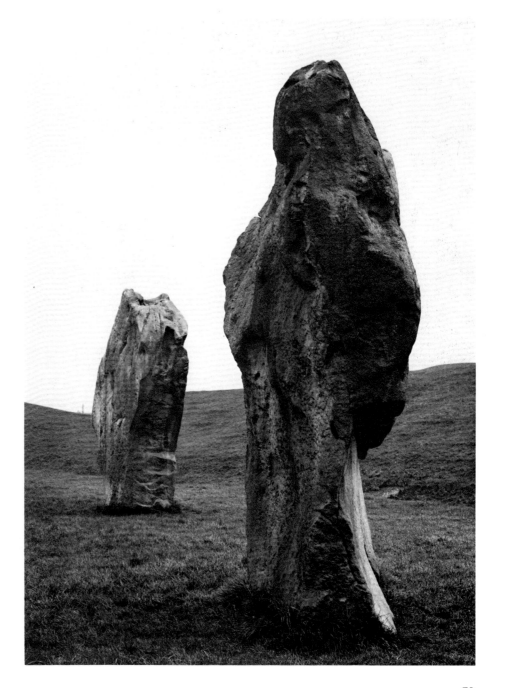

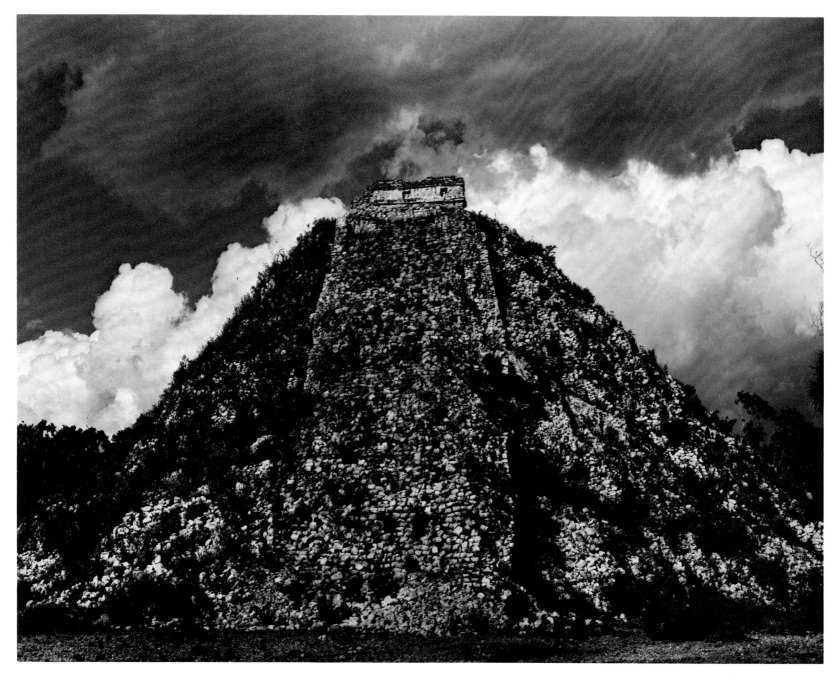

Opposite:
EDWARD RANNEY
Coba, Mexico. n.d.
8¼ x 10½ inches
The Museum of Modern Art,
New York
Purchase

RICHARD MISRACH
Stone #4 (Stonehenge #1). 1976
15¼ x 15⅛ inches
The Museum of Modern Art,
New York
Acquired with matching funds
from Shirley C. Burden and the
National Endowment for the Arts

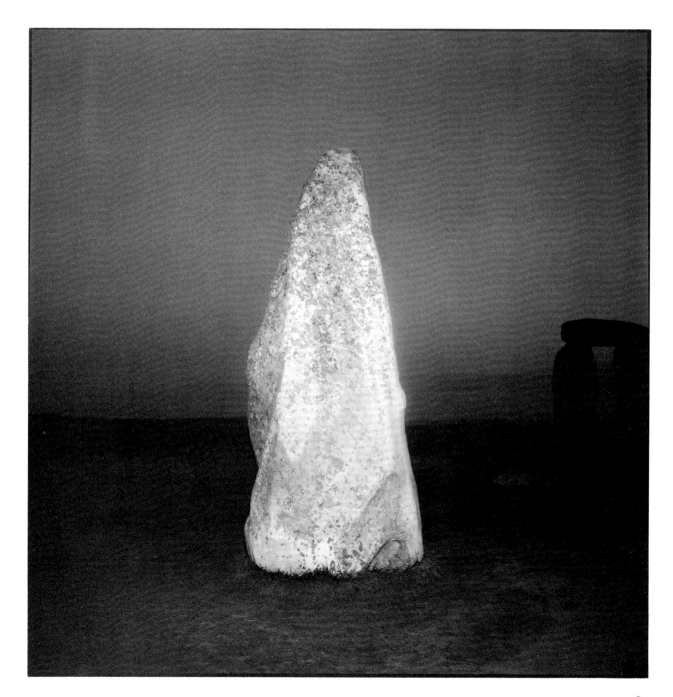

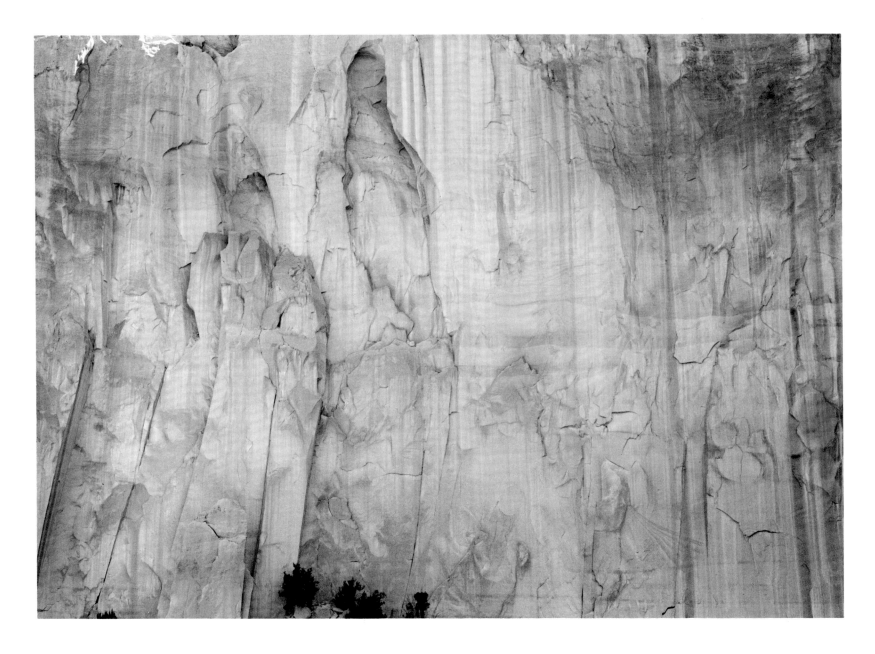

WILLIAM CLIFT. *The Enchanted Mesa, New Mexico*. 1975. 13¾ x 19 inches. The Museum of Modern Art, New York. Purchase

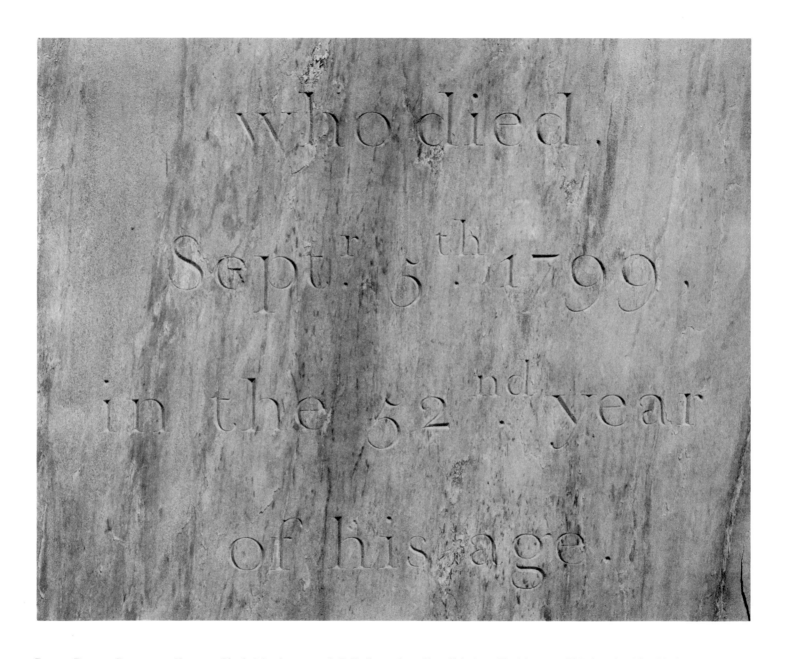

RICHARD BENSON, *Gravestone, Newport, Rhode Island*. 1977–78. Palladium print, 7⅜ x 9⅜ inches. The Museum of Modern Art, New York. Acquired with matching funds from Mrs. John D. Rockefeller 3rd and the National Endowment for the Arts

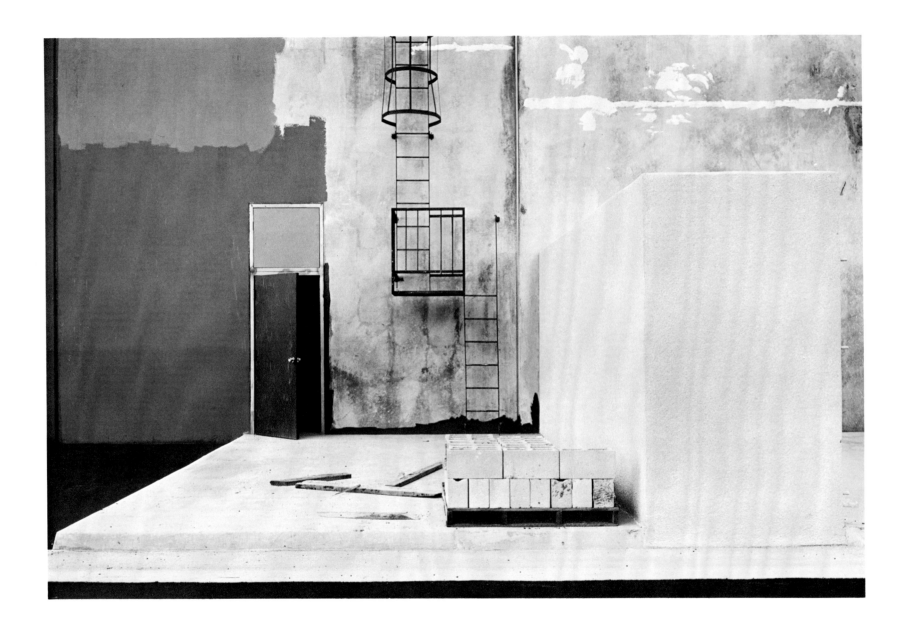

Opposite:
LEWIS BALTZ
Construction Detail, East Wall,
Xerox, 1821 Dyer Road, Santa Ana
1974. 6 x 9 inches
The Museum of Modern Art,
New York
Joseph G. Mayer Fund

JOHN M. DIVOLA, JR.
Untitled. 1974
7⅛ x 7⅛ inches
The Museum of Modern Art,
New York
Purchase

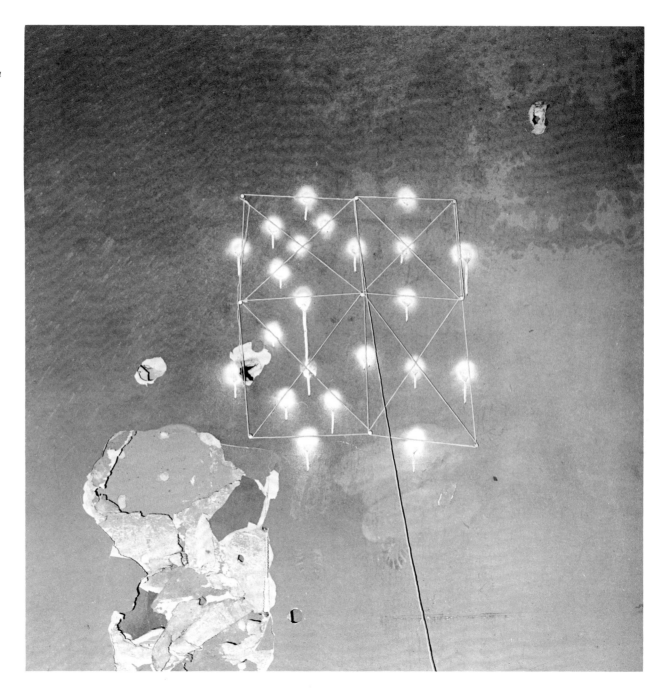

ROBERT MAPPLETHORPE
Tulips. 1977
14 x 13⅞ inches
The Museum of Modern Art,
New York
Acquired with matching funds
from David H. McAlpin and the
National Endowment for the Arts

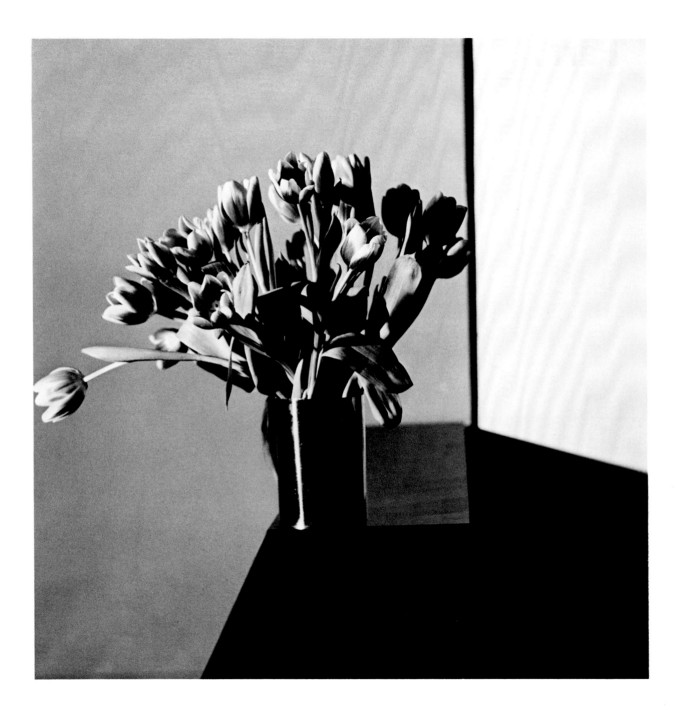

Part II

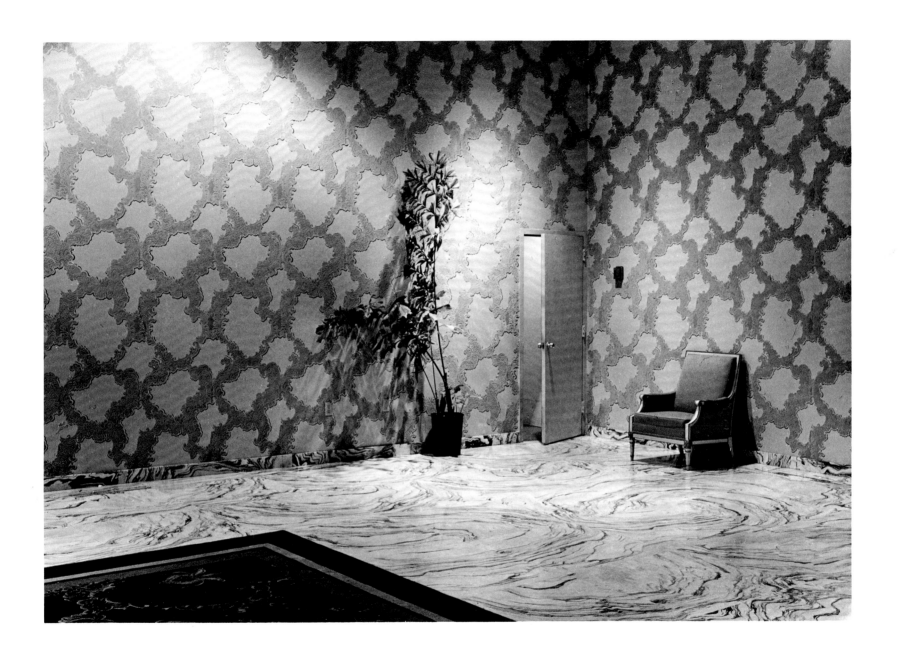

ELLIOTT ERWITT. *Fontainebleau Hotel, Miami Beach.* 1962. 9½ x 13½ inches. The Museum of Modern Art, New York. Gift of the photographer

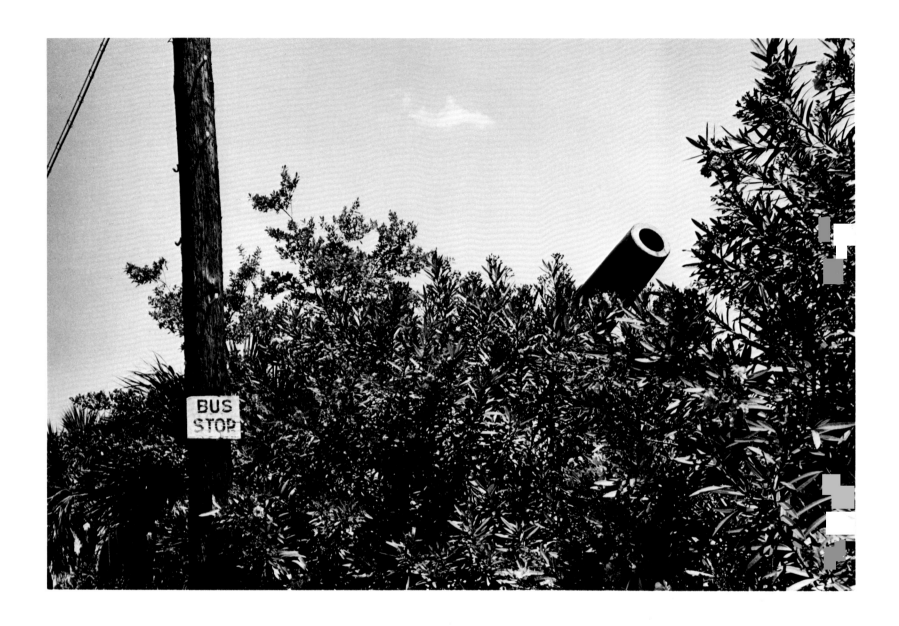

Opposite:
ELLIOTT ERWITT
New Jersey. 1953
8⅞ x 13⅜ inches
The Museum of Modern Art, New York
Gift of the photographer

GARRY WINOGRAND
New York. 1959
13½ x 8¾ inches
The Museum of Modern Art, New York
Gift of the photographer

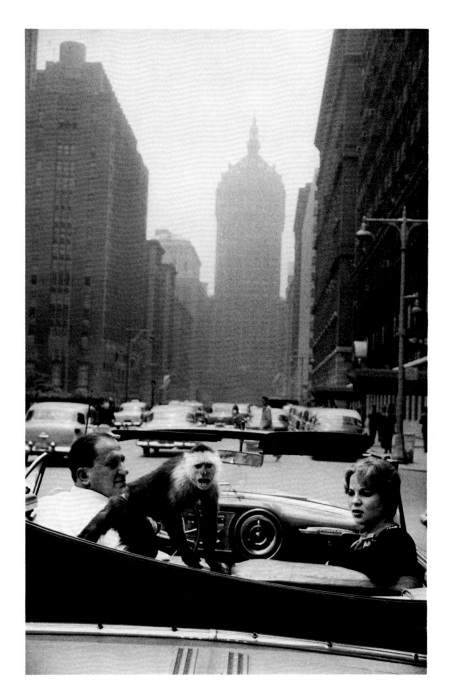

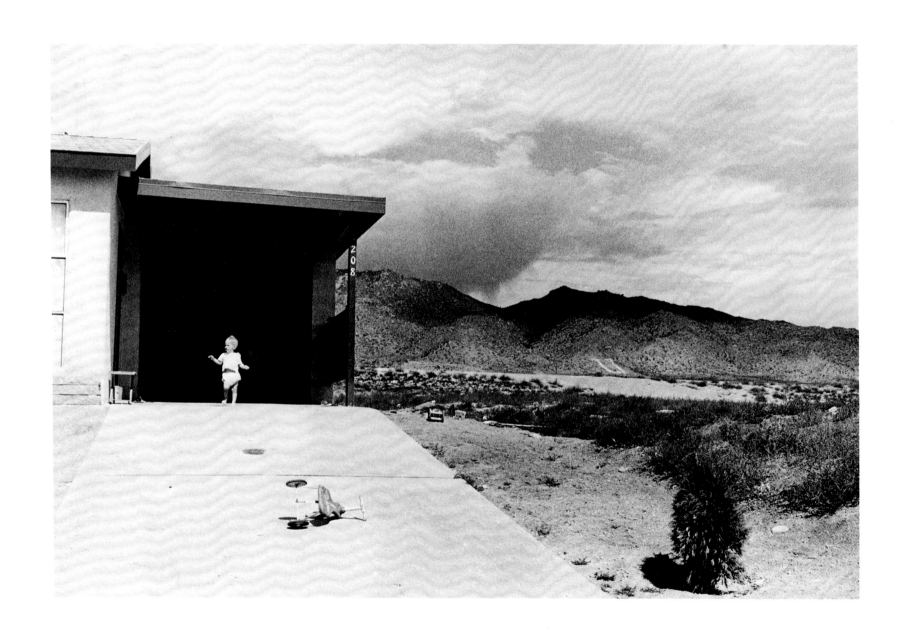

GARRY WINOGRAND. Untitled. 1957. 9 x 13⅛ inches. The Museum of Modern Art, New York. Purchase

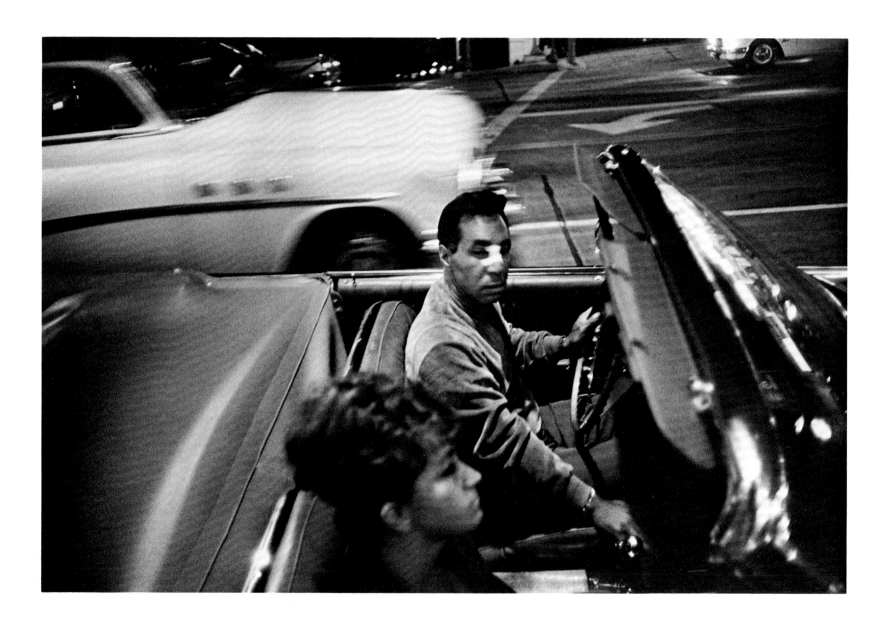

GARRY WINOGRAND. *Los Angeles*. 1964. 9 x 13⅜ inches. The Museum of Modern Art, New York. Purchase

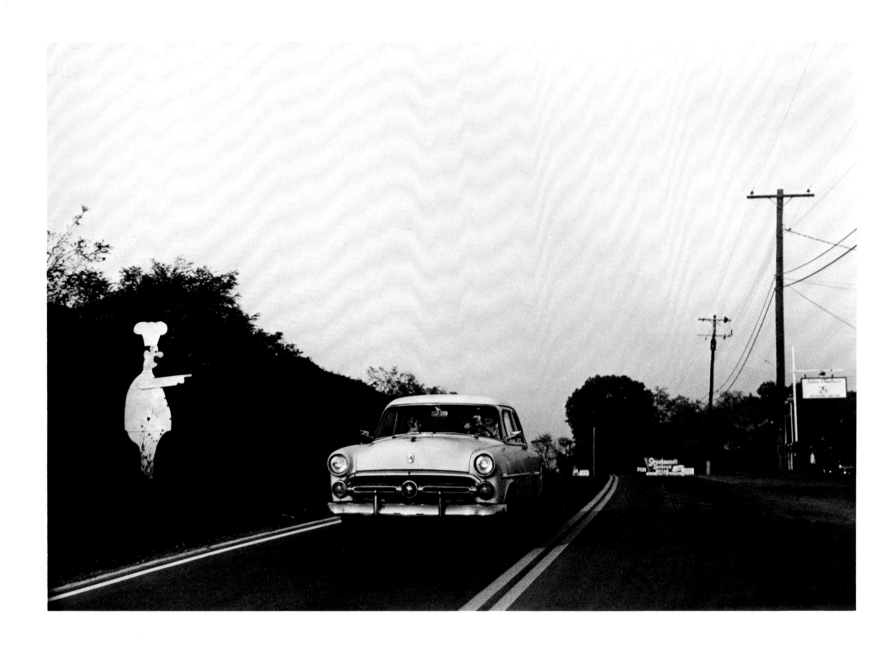

Opposite:
SIMPSON KALISHER
Untitled. 1962
9⅛ x 13⅜ inches
The Museum of Modern Art, New York
Ben Schultz Memorial Collection
Gift of the photographer

WILLIAM GEDNEY
Untitled. 1964
12 x 8¼ inches
The Museum of Modern Art, New York
Mr. and Mrs. John Spencer Fund

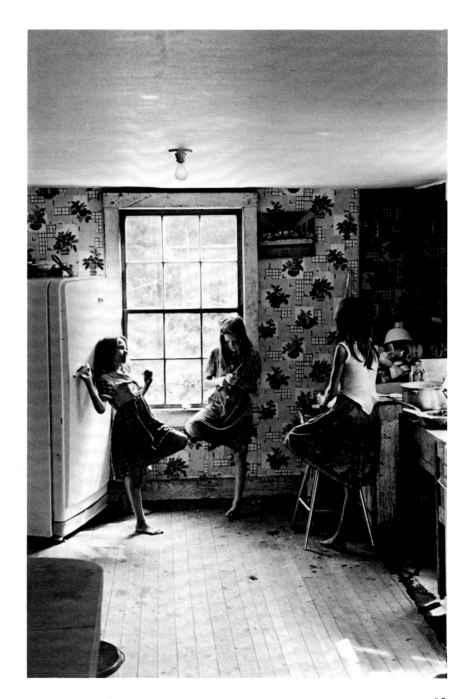

ART SINSABAUGH
Landscape Number 64. 1962
$3^7/_{16}$ x $19^3/_{16}$ inches
The Museum of Modern Art, New York
Purchase

Opposite:
WILLIAM CURRENT
California Sycamore Number 1. 1961
Two prints, overall 10½ x 21 inches
The Museum of Modern Art, New York
Purchase

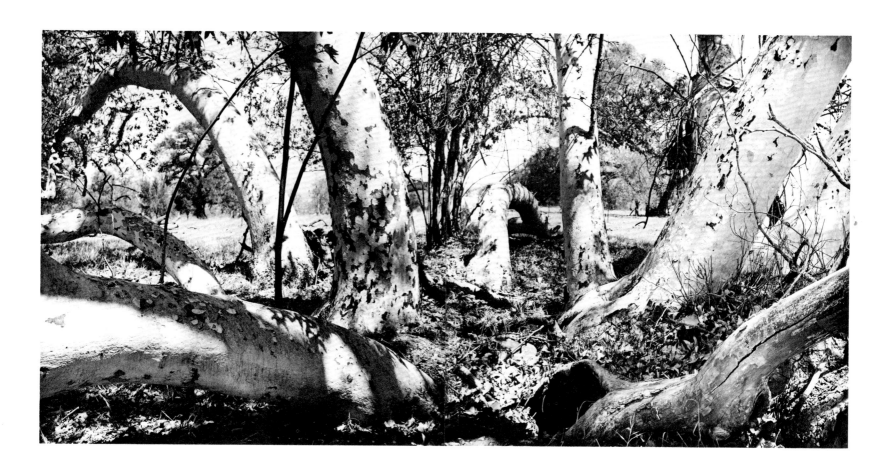

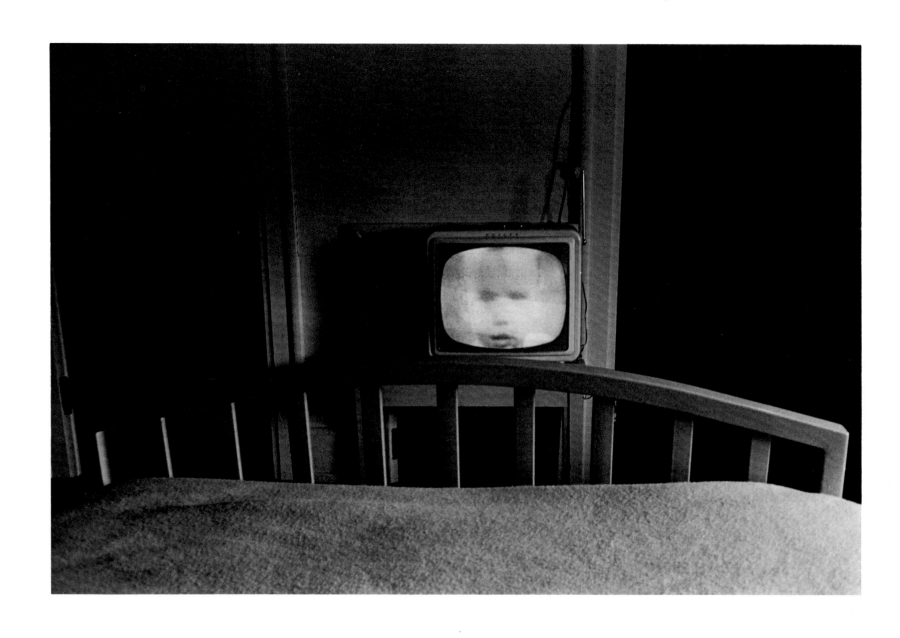

LEE FRIEDLANDER. *Galax, Virginia.* 1962. 5¹³/₁₆ x 8⅞ inches. The Museum of Modern Art, New York. Gift of Armand P. Bartos

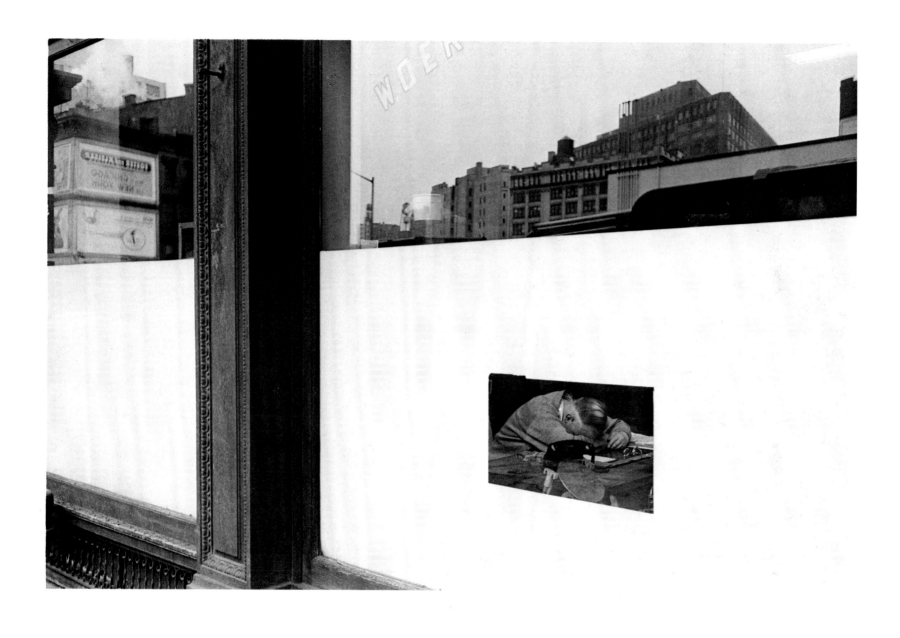

LEE FRIEDLANDER. *New York City*. 1964. 6⅜ x 9¾ inches. The Museum of Modern Art, New York. Purchase

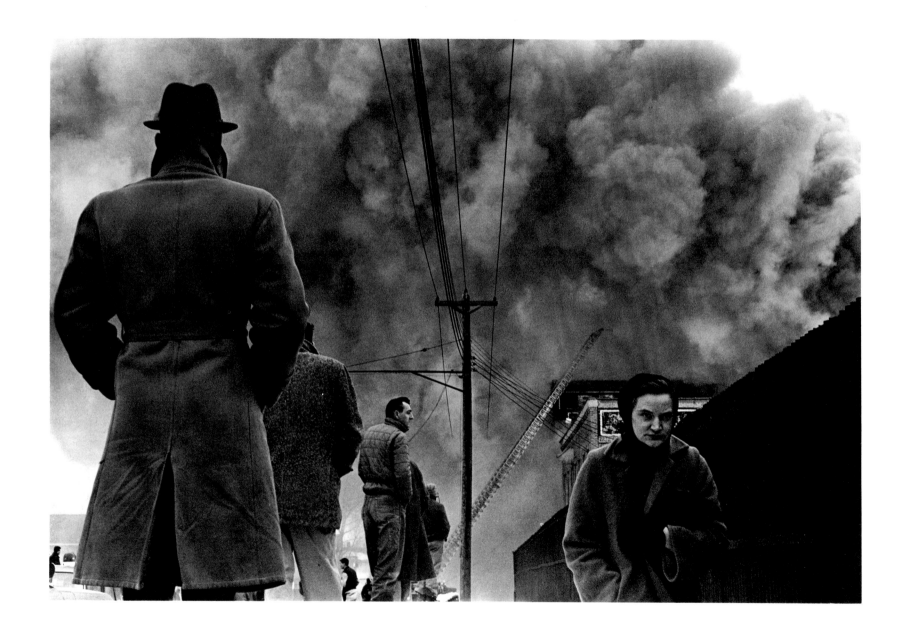

IRWIN B. KLEIN. *Minneapolis Fire*. 1962. 9 x 13⅜ inches. The Museum of Modern Art, New York. Purchase

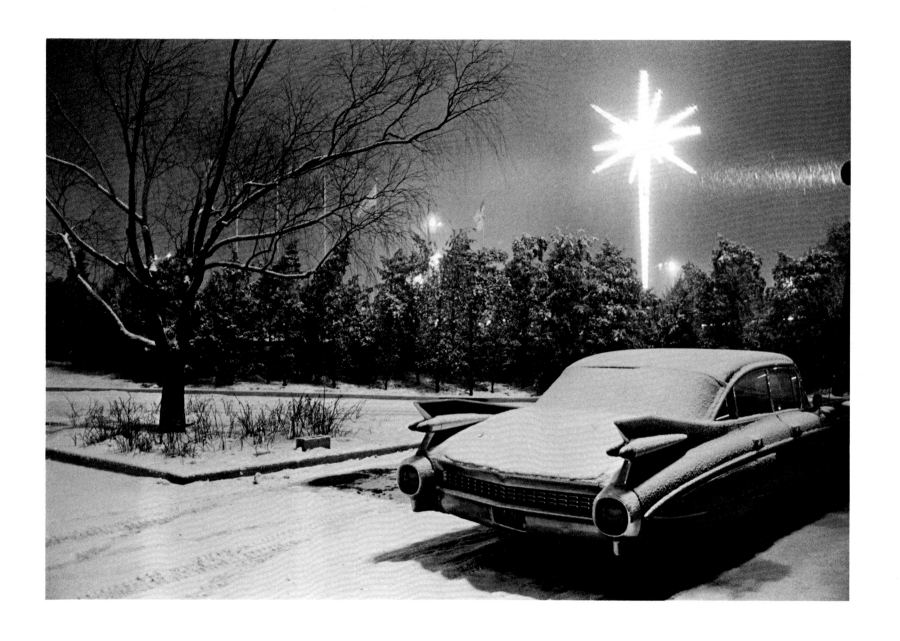

JOEL MEYEROWITZ. *Christmas, Kennedy Airport*. 1967. 9 x 13½ inches. The Museum of Modern Art, New York. Purchase

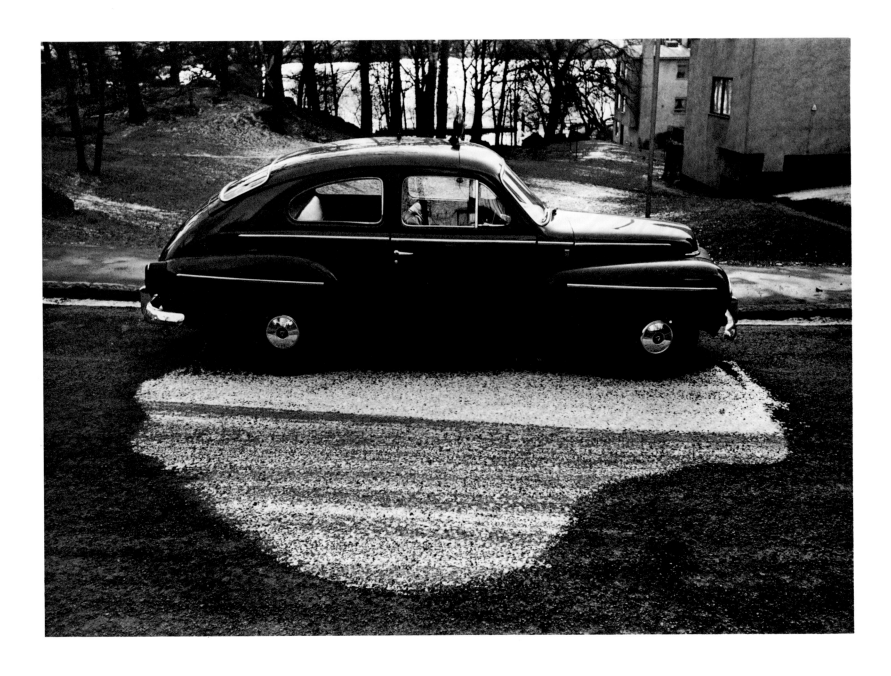

KEN JOSEPHSON. *Stockholm*. 1967. 6½ x 9 inches. The Museum of Modern Art, New York. Purchase

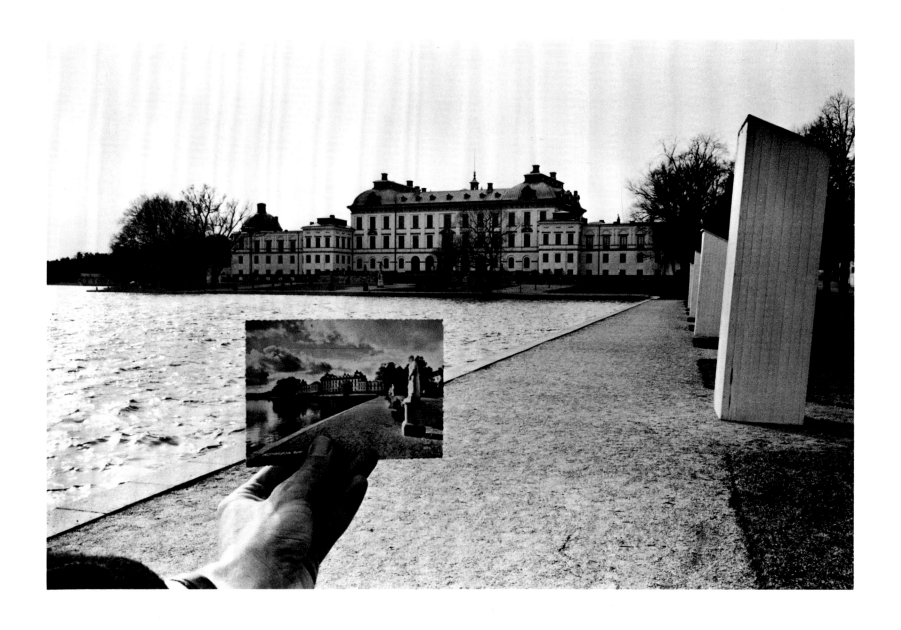

KEN JOSEPHSON. *Drottningholm, Sweden.* 1967. 5⅞ x 9 inches. The Museum of Modern Art, New York. Purchase

Opposite:
MICHAEL CIAVOLINO
Boat Ride, Rye Beach. 1962
13½ x 16¼ inches
The Museum of Modern Art, New York
Purchase

SYLVIA PLACHY
The Confrontation. 1965
21 x 17⅜ inches
The Museum of Modern Art, New York
Benjamin Zeller Memorial Fund

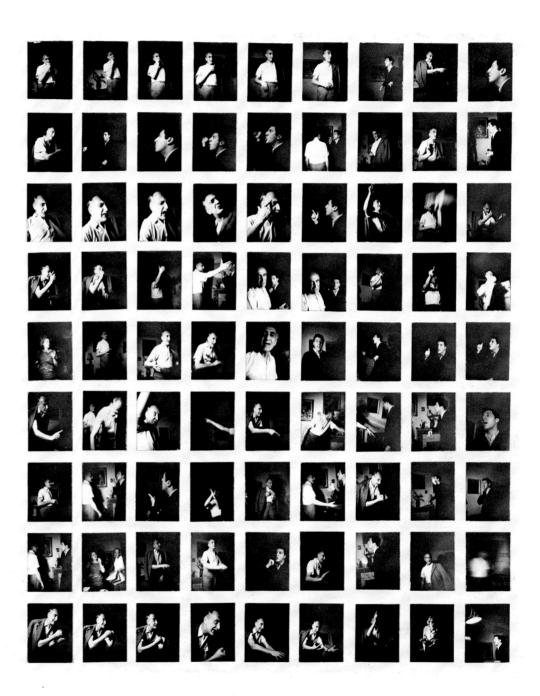

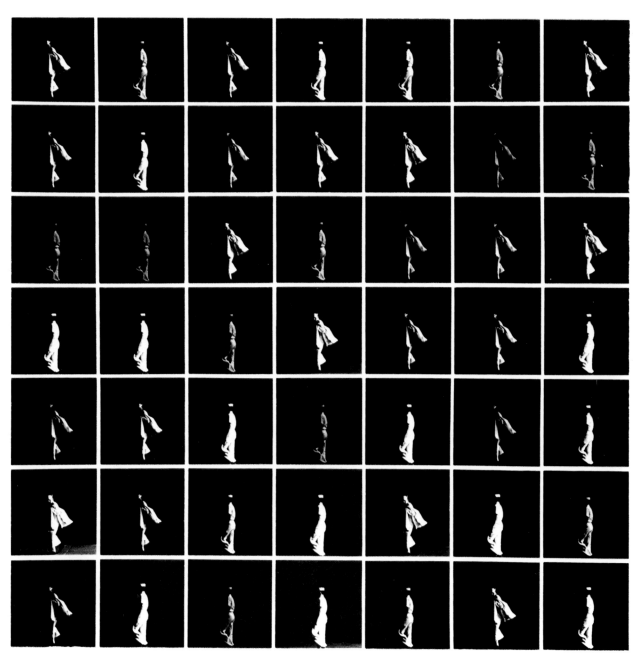

RAY K. METZKER. Untitled. c. 1964. Photomosaic, 12¾ x 13 inches. The Philadelphia Museum of Art

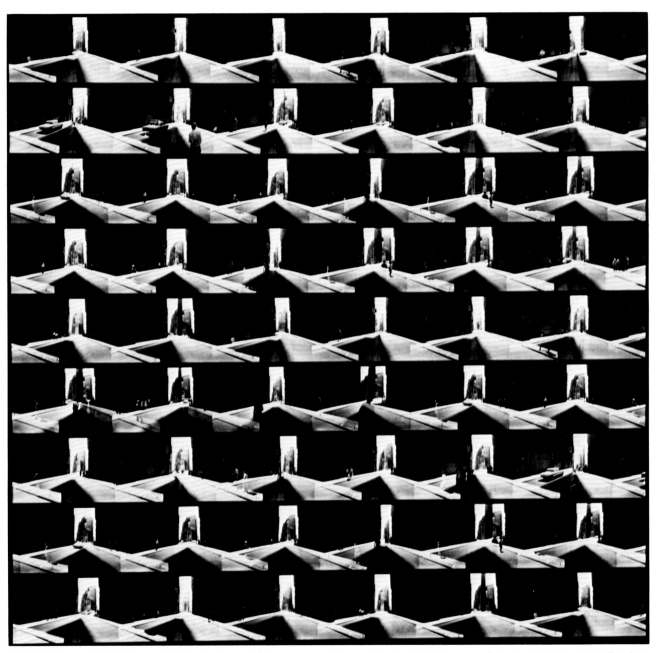

RAY K. METZKER. Untitled. c. 1966. Overlapping multiple exposure, 32¼ x 34¾ inches. The Museum of Modern Art, New York. Purchase

Opposite:
RAY K. METZKER
Untitled. c. 1969
9⅛ x 6⅝ inches
The Museum of Modern Art, New York
Purchase

TETSU OKUHARA
Untitled. 1971
Photomosaic, 34¾ x 24 inches
The Museum of Modern Art, New York
David H. McAlpin Fund

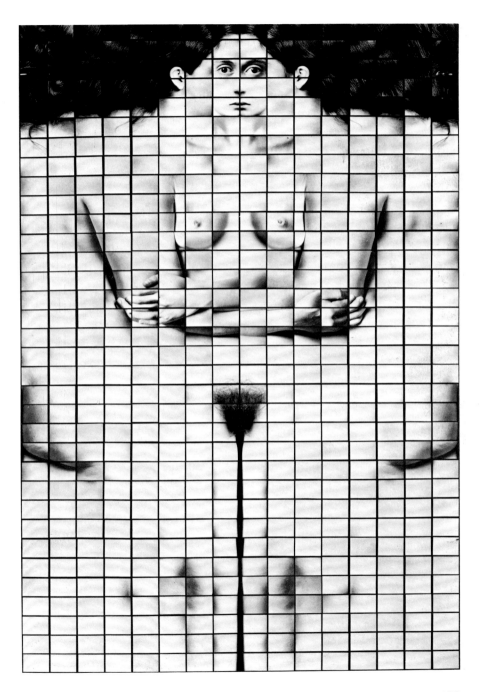

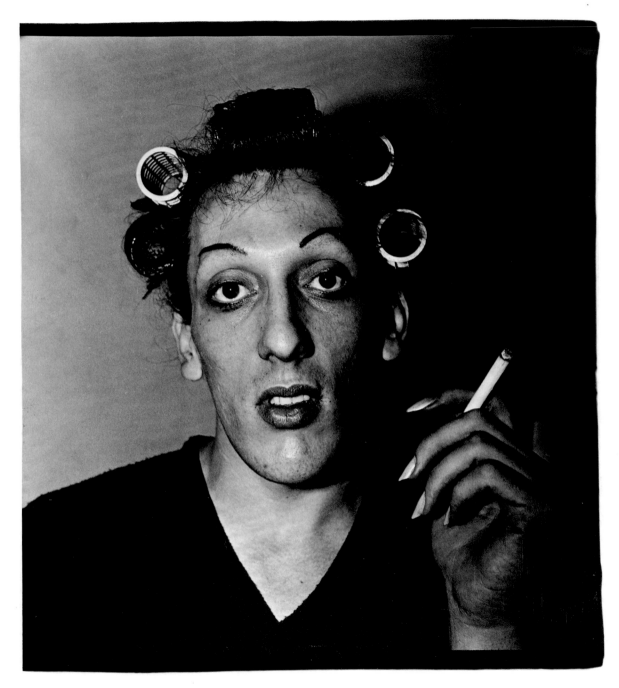

DIANE ARBUS
A Young Man in Curlers at Home
on West 20th Street, New York City. 1966.
14¾ x 14 inches
The Museum of Modern Art,
New York. Purchase

Opposite:
DIANE ARBUS
Untitled. 1970– 71
14¾ x 14⅝ inches
The Museum of Modern Art,
New York
Mrs. Armand P. Bartos Fund

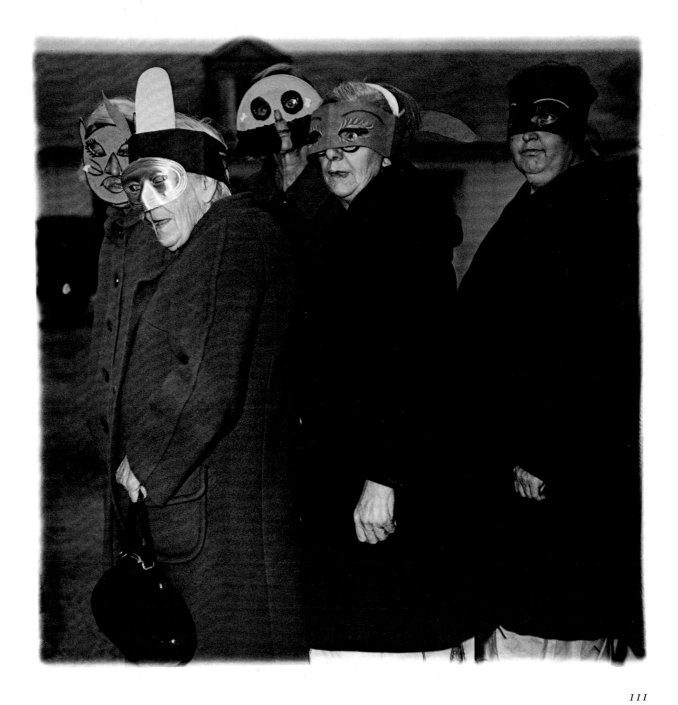

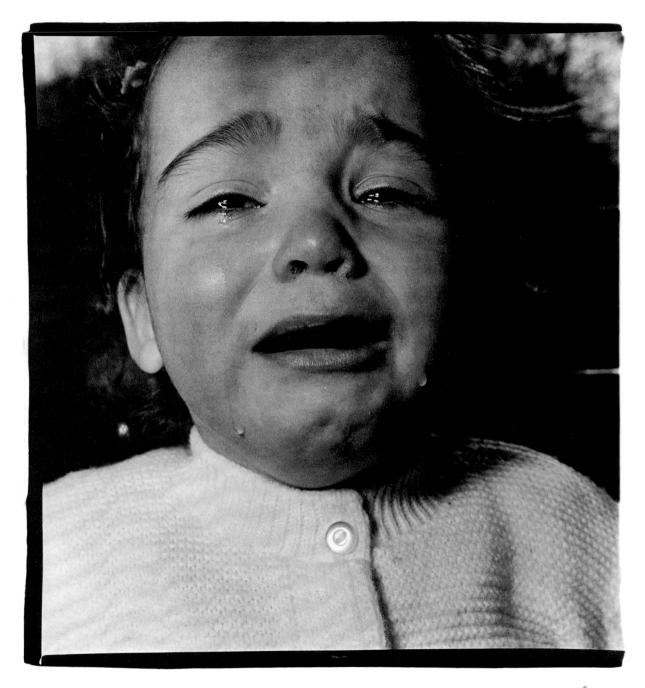

DIANE ARBUS
A Child Crying, New Jersey. 1967
16 x 15⅝ inches
The Museum of Modern Art,
New York
Mrs. Douglas Auchincloss Fund

Opposite:
DIANE ARBUS
Man at a Parade on Fifth Avenue,
New York City. 1969
14¼ x 14¼ inches
The Museum of Modern Art,
New York
Mrs. Armand P. Bartos Fund

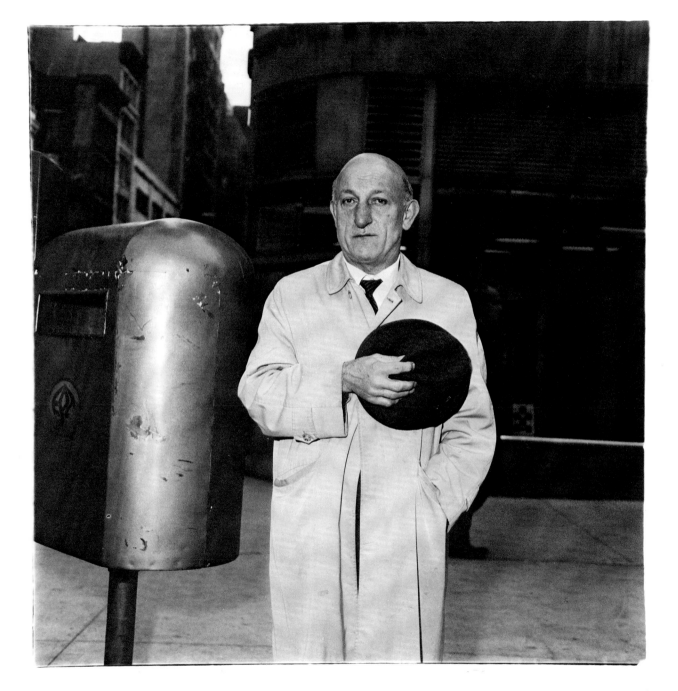

Two plates from *Thirtyfour Parking Lots in Los Angeles*
(Los Angeles: 1967)
Left: *State Board of Equalization, 14601 Sherman Way, Van Nuys*. n.d.
Right: *7101 Sepulveda Blvd., Van Nuys*. n.d.

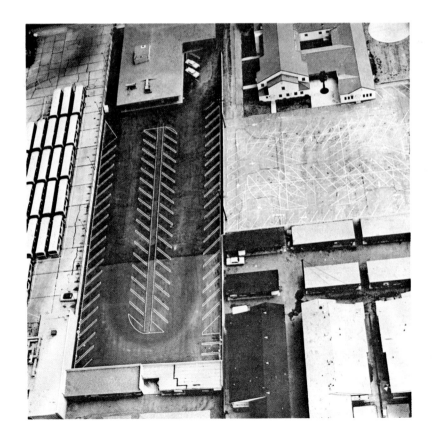

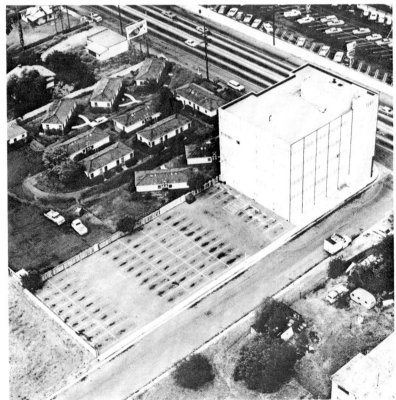

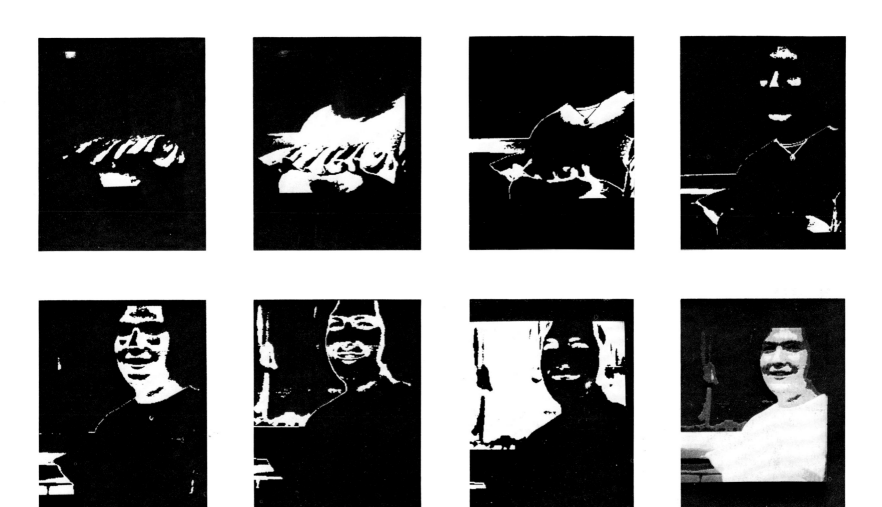

Computer-analyzed picture reducing continuous-toned image
to component brightness levels. 1966
Collection the photographer

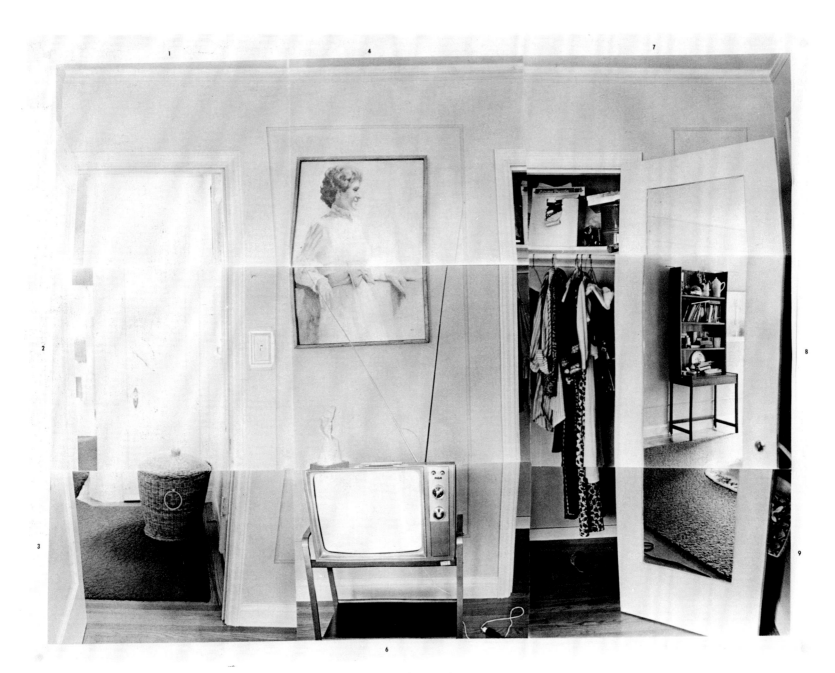

LEW THOMAS. *9 Perspectives*. 1972. Photomosaic, 48 x 60 inches. Collection the photographer

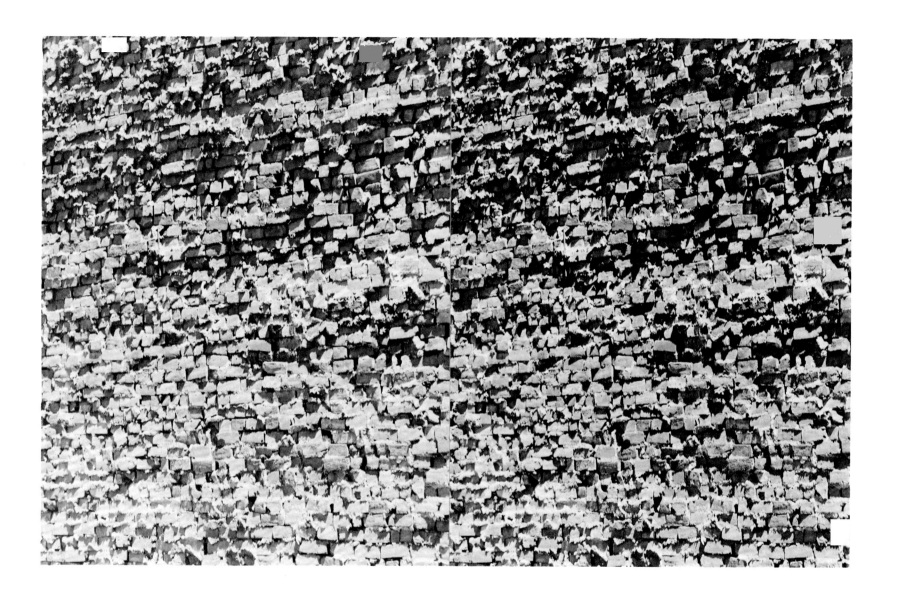

Sol LeWitt. *Brick Wall*. 1977. Two prints, overall 10⅞ x 17⅛ inches. The Museum of Modern Art, New York
Acquired with matching funds from Mrs. John D. Rockefeller 3rd and the National Endowment for the Arts

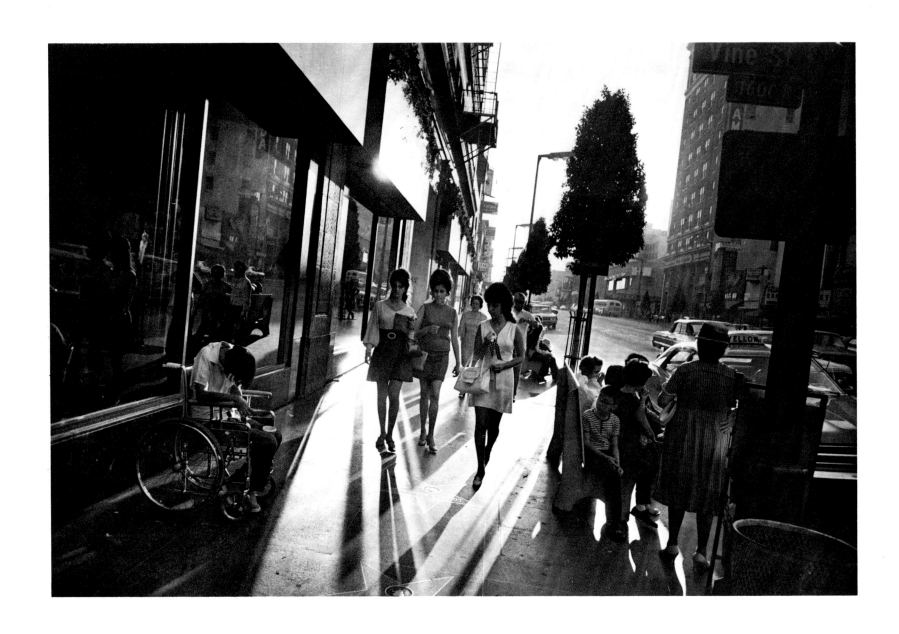

GARRY WINOGRAND. *Los Angeles, California*. 1969. 8½ x 12⅞ inches. Collection N. Carol Lipis, New York

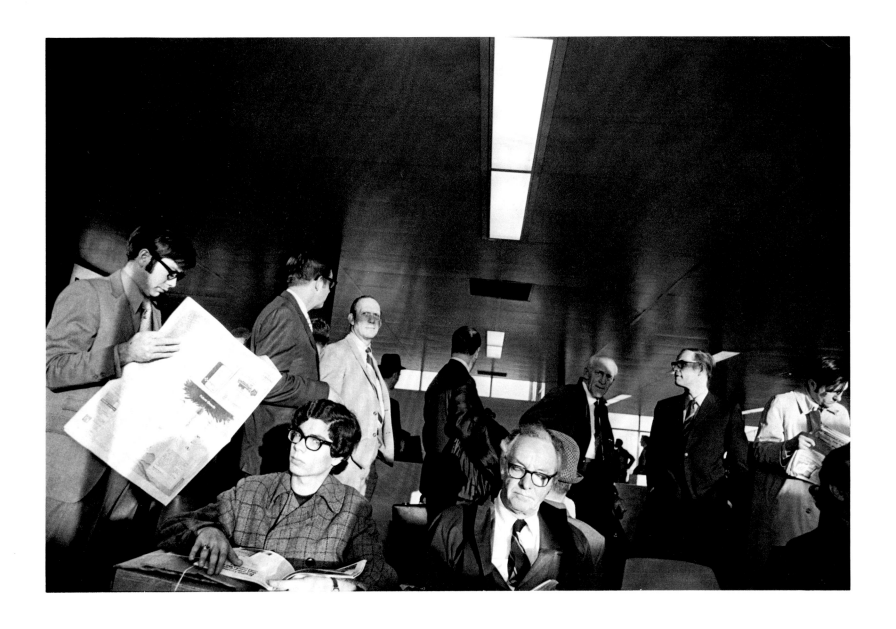

Garry Winogrand. *New York City Airport*. c. 1972. 8¾ x 13 inches. The Museum of Modern Art, New York. Purchase

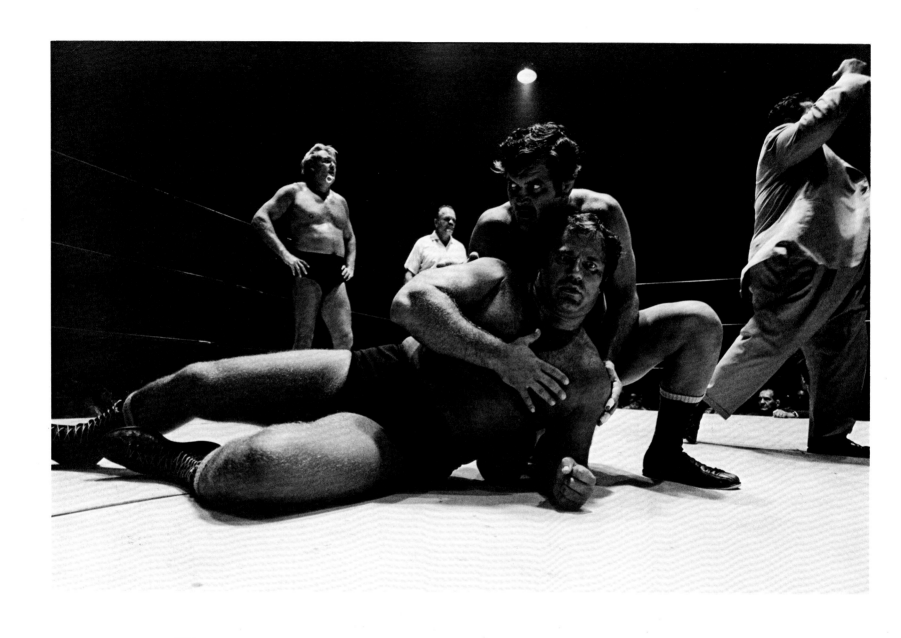

GEOFF WINNINGHAM. *Tag Team Action*. 1971. 12¼ x 18¼ inches. The Museum of Modern Art, New York. John Spencer Fund

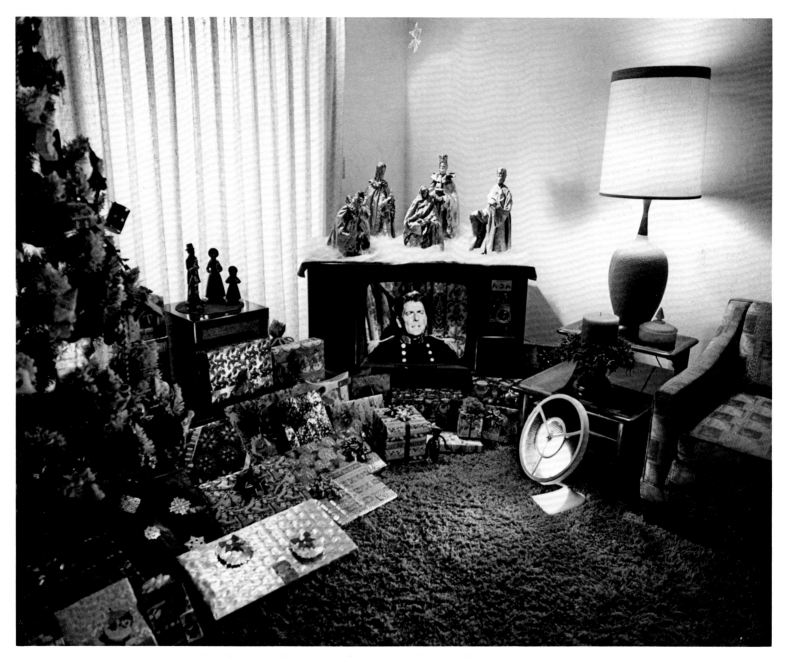

BILL OWENS. *Ronald Reagan.* 1972. 10⅞ x 13⅞ inches. The Museum of Modern Art, New York. Purchase

Bill Zulpo-Dane. Four postcards. Each approx. 6½ x 4⅜ inches. The Museum of Modern Art, New York. Gift of the photographer
Left to right: *North California Coast*. 1975. *Las Vegas*. 1973. *Berkeley*. 1975. *Waikiki*. 1976

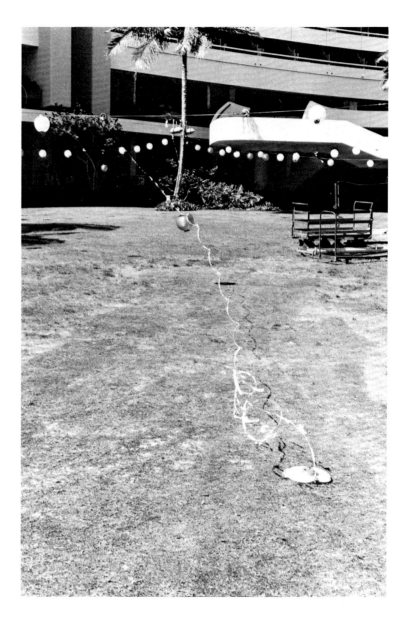

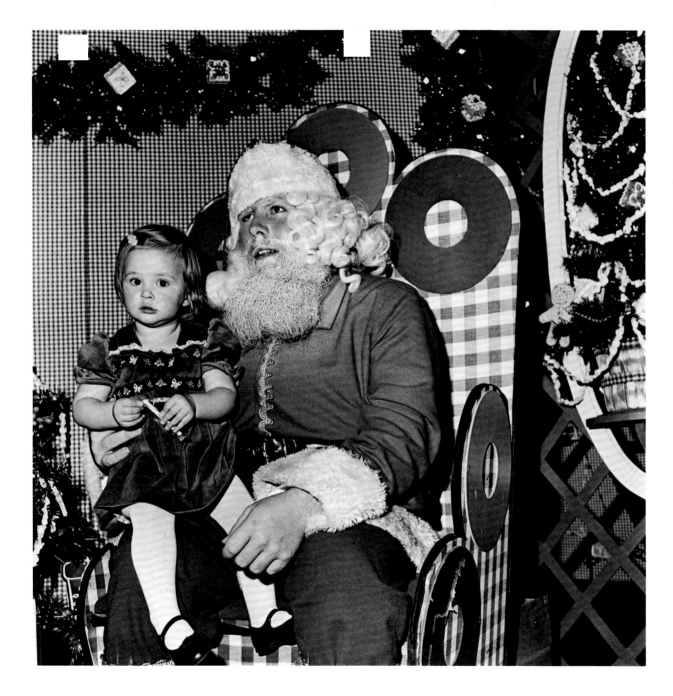

ROSALIND SOLOMON
Untitled. 1975
15⅜ x 15¼ inches
The Museum of Modern Art,
New York
Gift of the photographer

Opposite:
CHAUNCEY HARE
Escalon Hotel before Demolishment,
San Joaquin Valley, California. 1968
8⅝ x 12⅛ inches
The Museum of Modern Art,
New York. Purchase

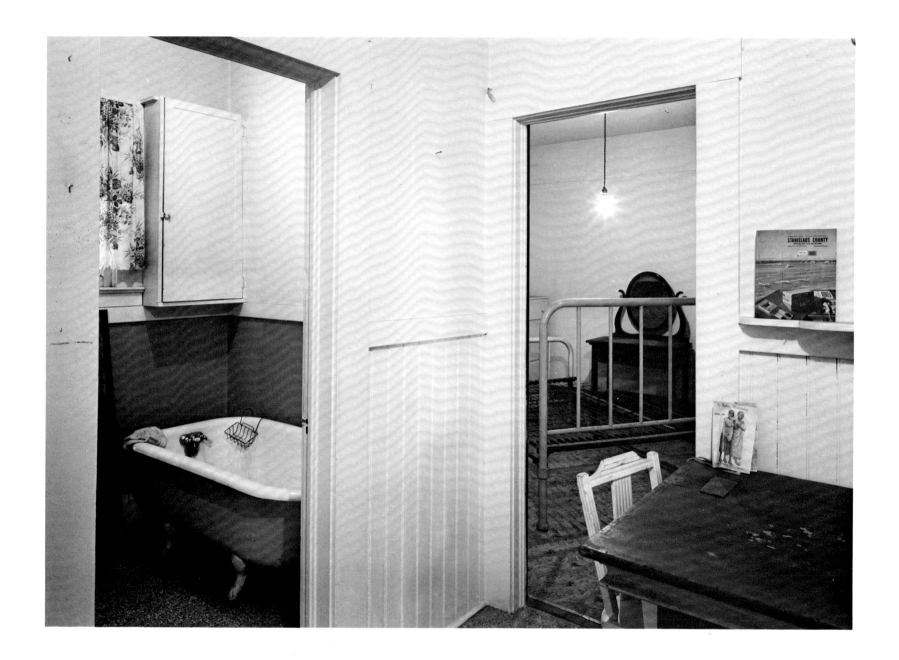

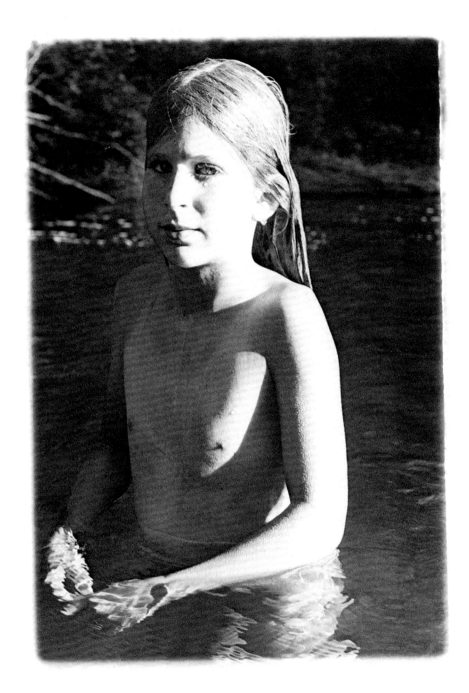

SHEILA METZNER
Evyan. 1975
17½ x 12 inches
The Museum of Modern Art, New York
Gift of the photographer

Opposite:
RICHARD P. HUME
Untitled. 1974
8 x 12 inches
The Museum of Modern Art, New York
Purchase

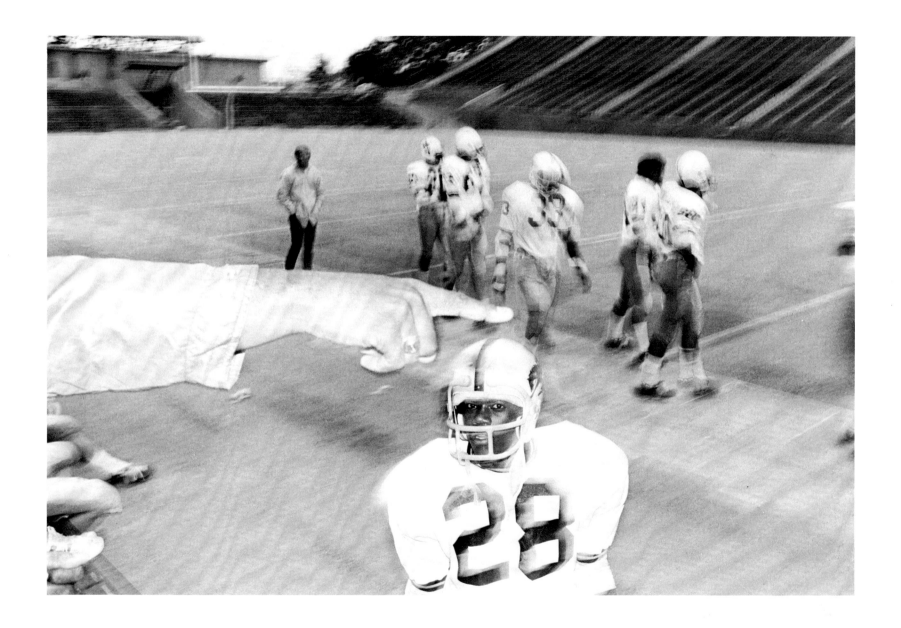

ELIOT PORTER
Red Osier. 1945
Dye transfer print, $10^{7}/_{16}$ x $7^{7}/_{8}$ inches
The Museum of Modern Art, New York
Gift of the photographer

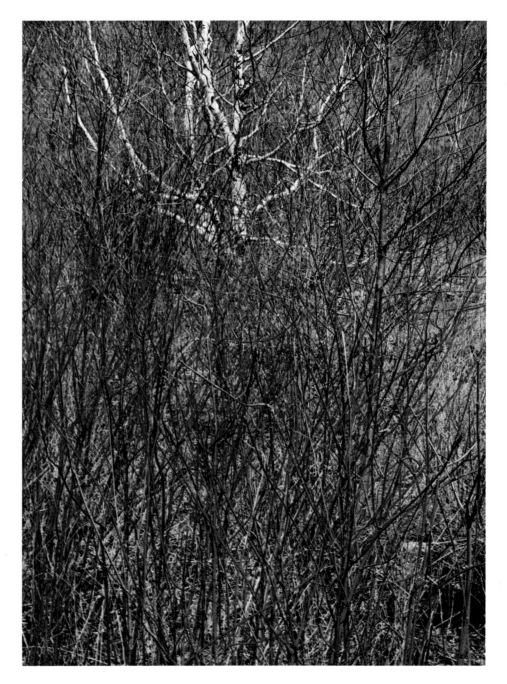

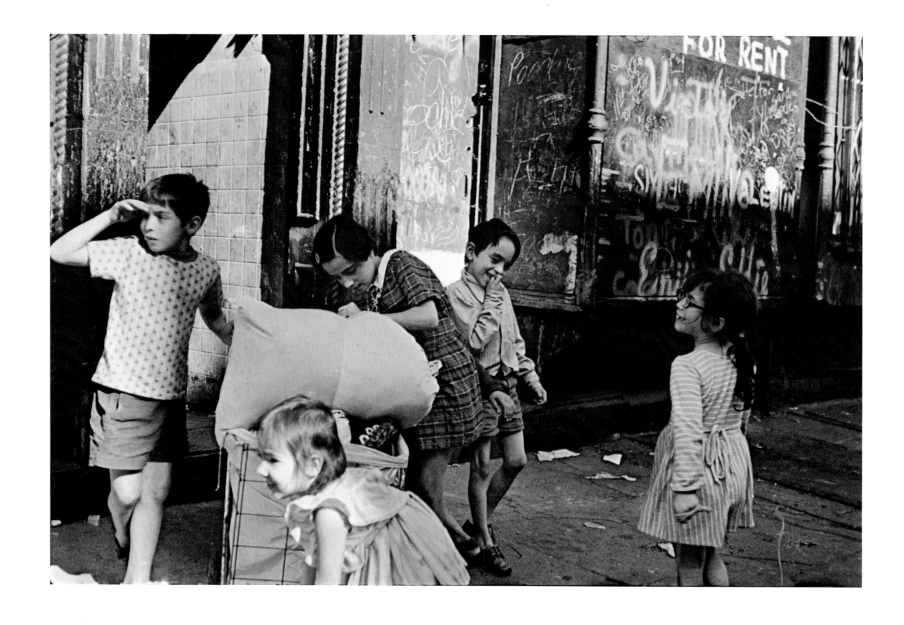

HELEN LEVITT. Untitled. 1972–74. Dye transfer print, 9¼ x 14¼ inches. The Museum of Modern Art, New York. Gilman Foundation Fund

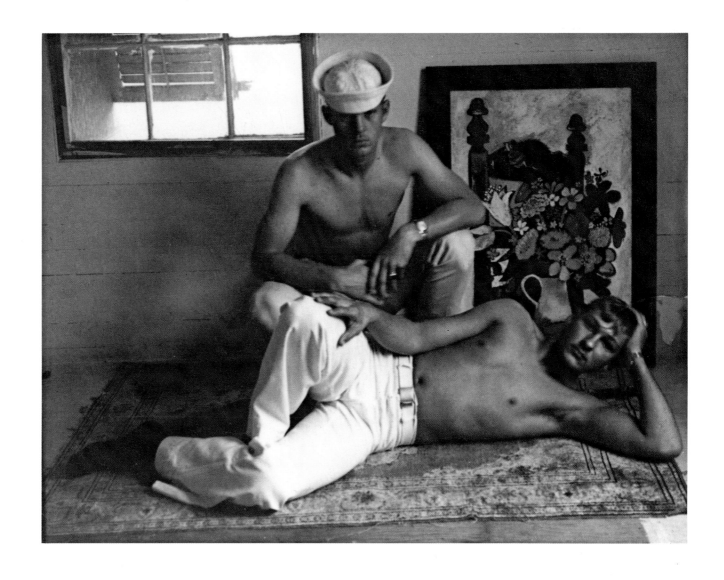

Marie Cosindas. *Sailors. Key West.* 1966. Dye transfer print from Polacolor original, 5⅜ x 7 inches. The Museum of Modern Art, New York. Acquired with matching funds from Samuel Wm. Sax and the National Endowment for the Arts

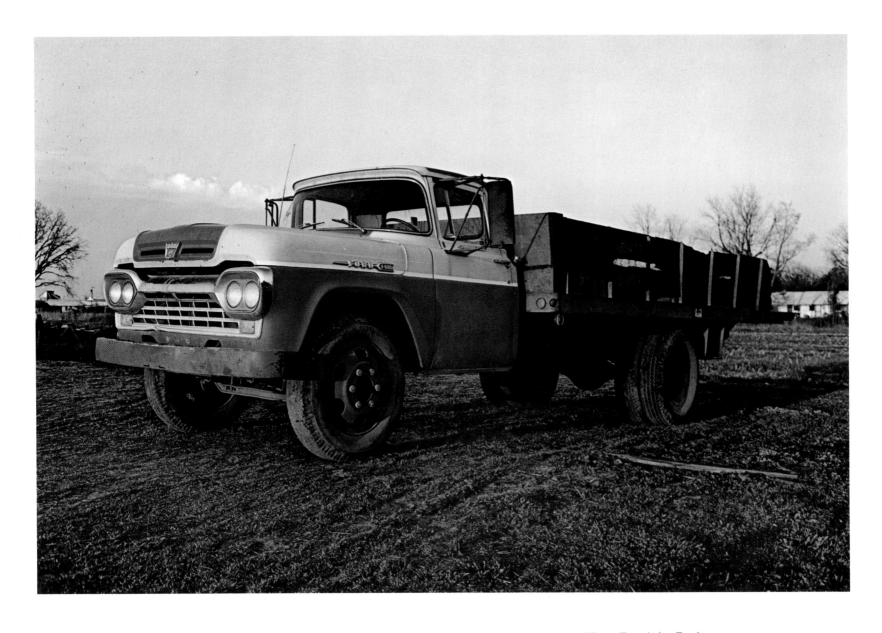

WILLIAM EGGLESTON. *Memphis*. c. 1971. Dye transfer print, 13 x 19⅜ inches. The Museum of Modern Art, New York. Gilman Foundation Fund

Opposite: STEPHEN SHORE. *Meeting Street, Charleston, South Carolina*. 1975. Type C print, 12 x 15 inches. The Museum of Modern Art, New York. Gift of John R. Jakobson Foundation, Inc.

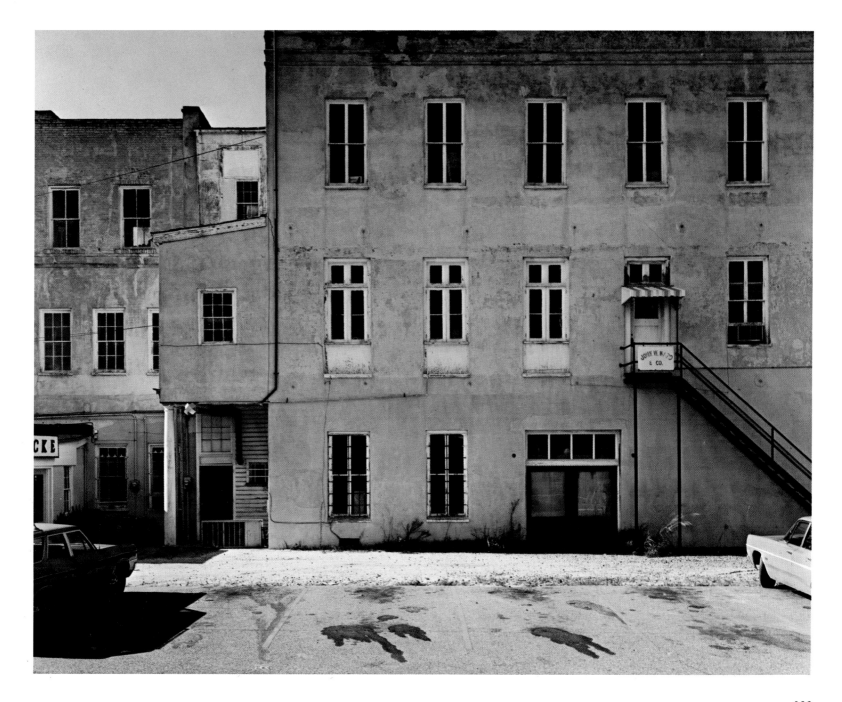

133

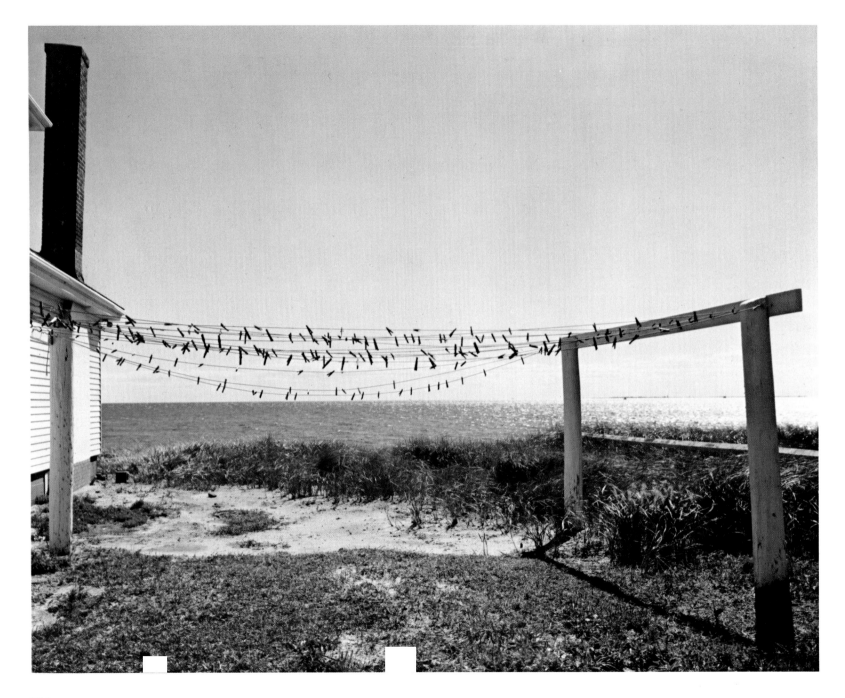

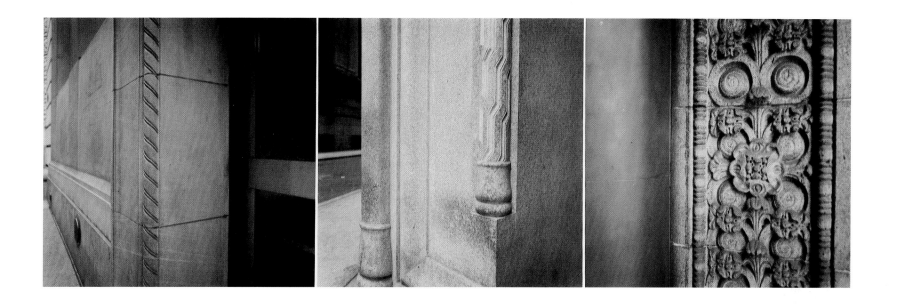

Jan Groover. Untitled. 1977. Type C prints, each 15 x 15 inches; overall 15 x 45¼ inches. The Museum of Modern Art, New York.
Acquired with matching funds from Mrs. John D. Rockefeller 3rd and the National Endowment for the Arts

Opposite: Joel Meyerowitz. Untitled. 1976. Type C print, 7⅝ x 9⅝ inches. The Museum of Modern Art, New York. Purchase

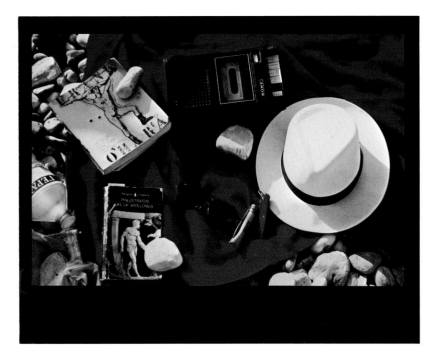 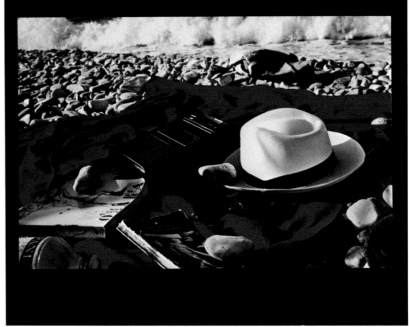

Eve Sonneman. *Sight/Sound: For Mike Goldberg, Samos, Greece.* 1977. Cibachrome prints, each 8 x 10 inches. The Museum of Modern Art, New York. Acquired with matching funds from Samuel Wm. Sax and the National Endowment for the Arts

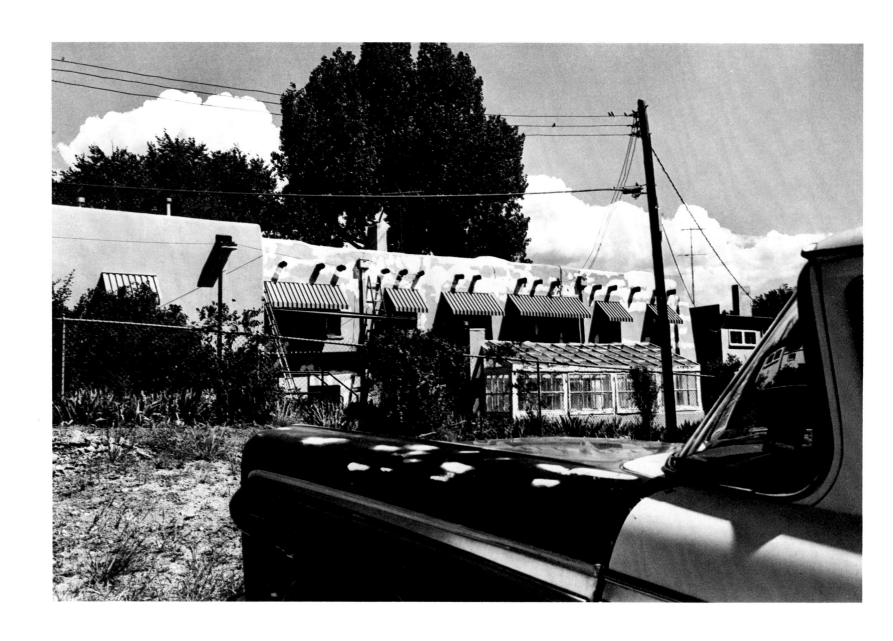

Tod Papageorge. *Santa Fe, New Mexico*. 1969. 9 x 13½ inches. The Museum of Modern Art, New York. Purchase

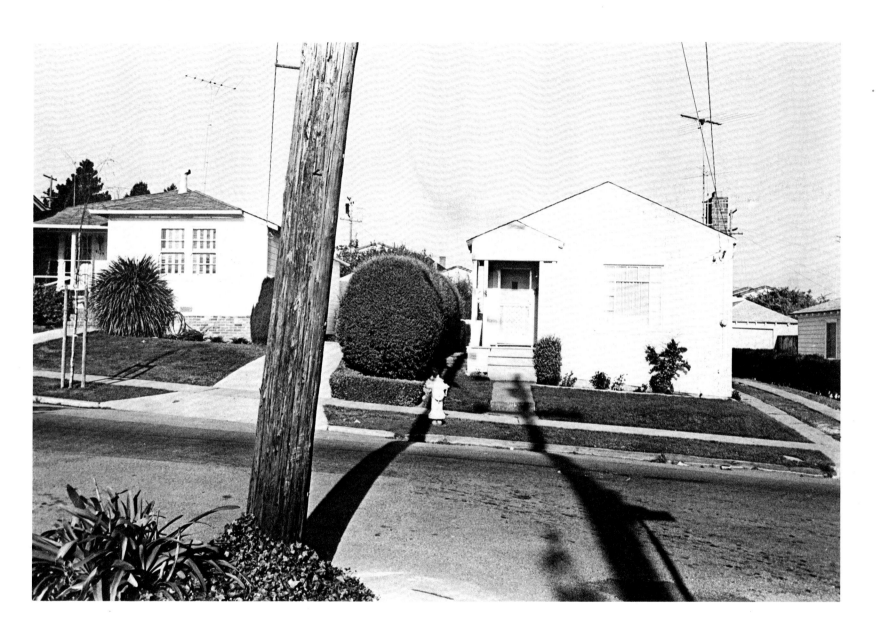

HENRY WESSEL, JR. Untitled. 1972. 8 x 12 inches. The Museum of Modern Art, New York. John Spencer Fund

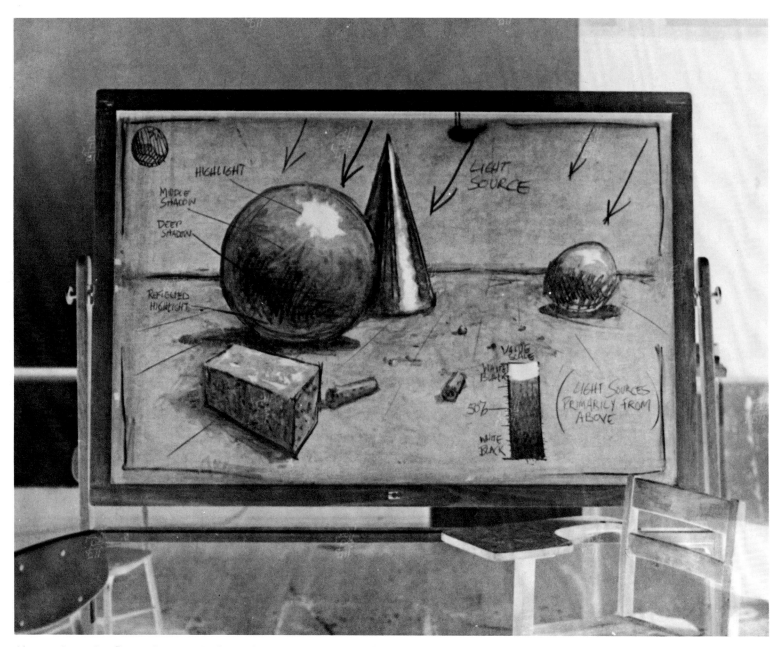

Above and opposite: ROBERT CUMMING. *Academic Shading Exercise.* 1974. Print and paper-negative print, each 8 x 10 inches. Collection the photographer

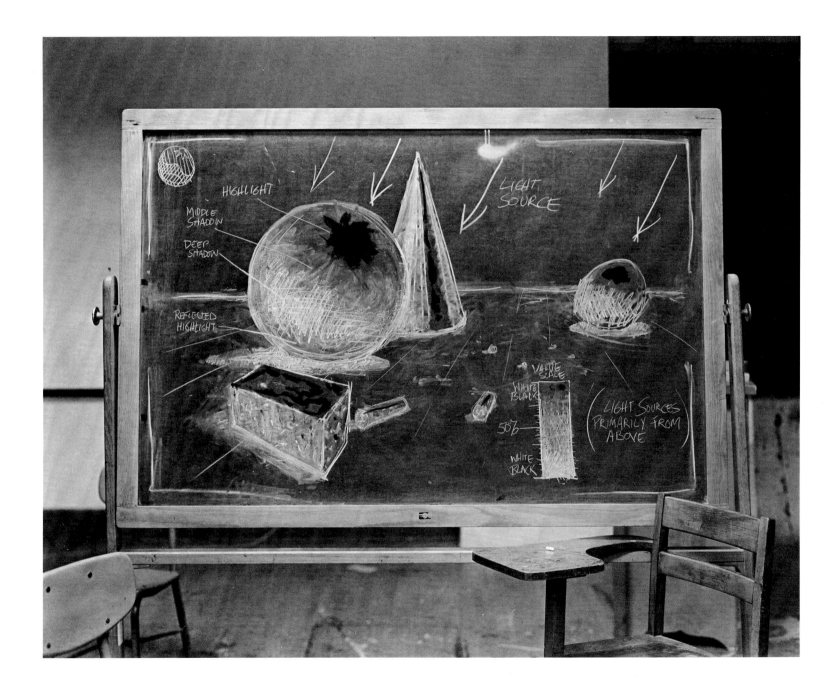

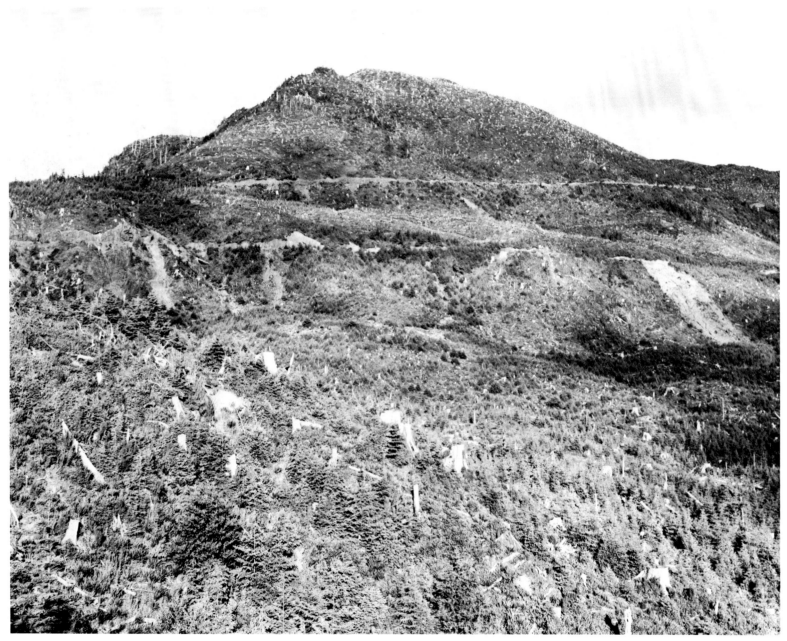

ROBERT ADAMS. *Burned and Clearcut, West of Arch Cape, Oregon.* 1976. 7 x 8¾ inches. The Museum of Modern Art, New York
Acquired with matching funds from Samuel Wm. Sax and the National Endowment for the Arts

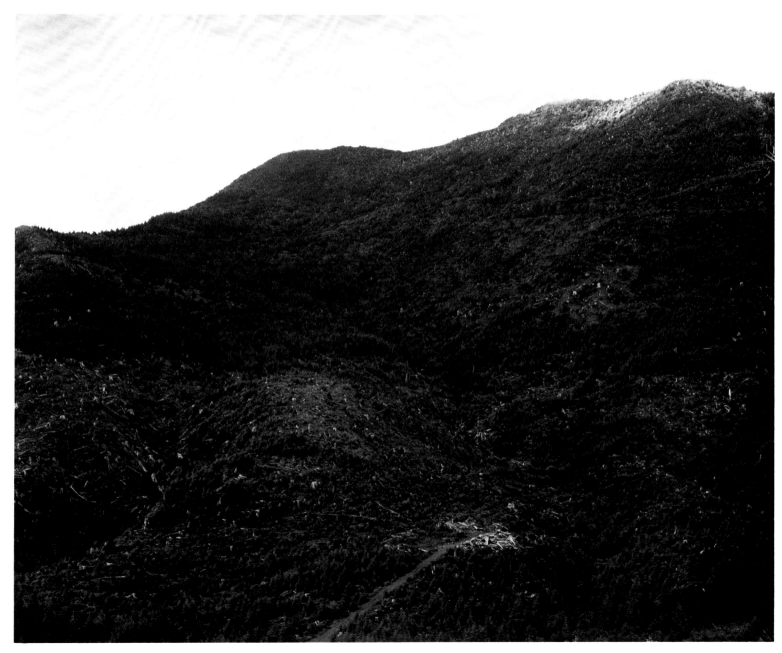

ROBERT ADAMS. *Burned and Clearcut, West of Arch Cape, Oregon.* 1976. 7 x 8¾ inches. The Museum of Modern Art, New York
Acquired with matching funds from Samuel Wm. Sax and the National Endowment for the Arts

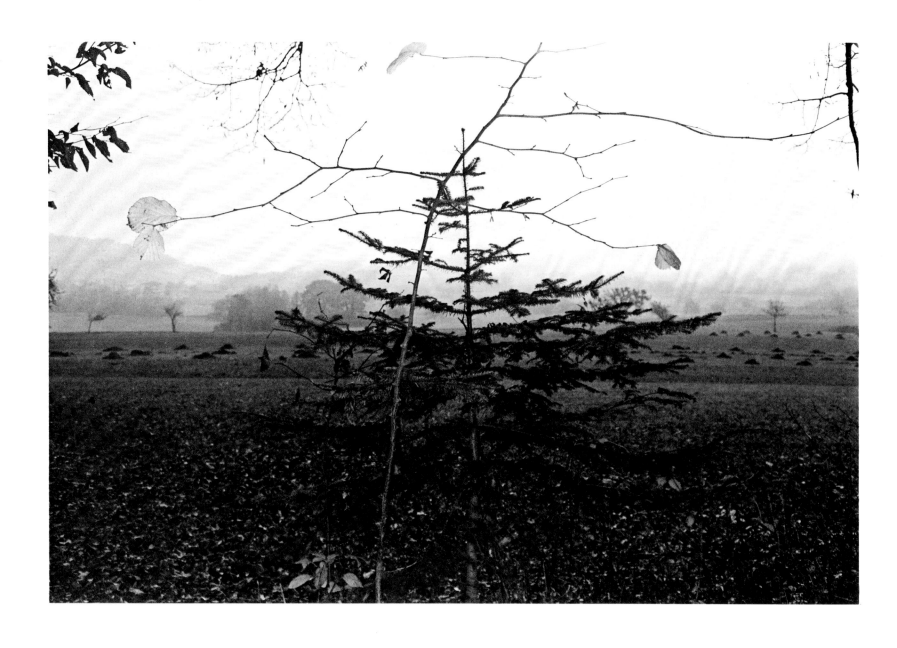

LEE FRIEDLANDER. *Switzerland.* 1972. 6⅞ x 10¼ inches. The Museum of Modern Art, New York. Gift of Mrs. John D. Rockefeller 3rd

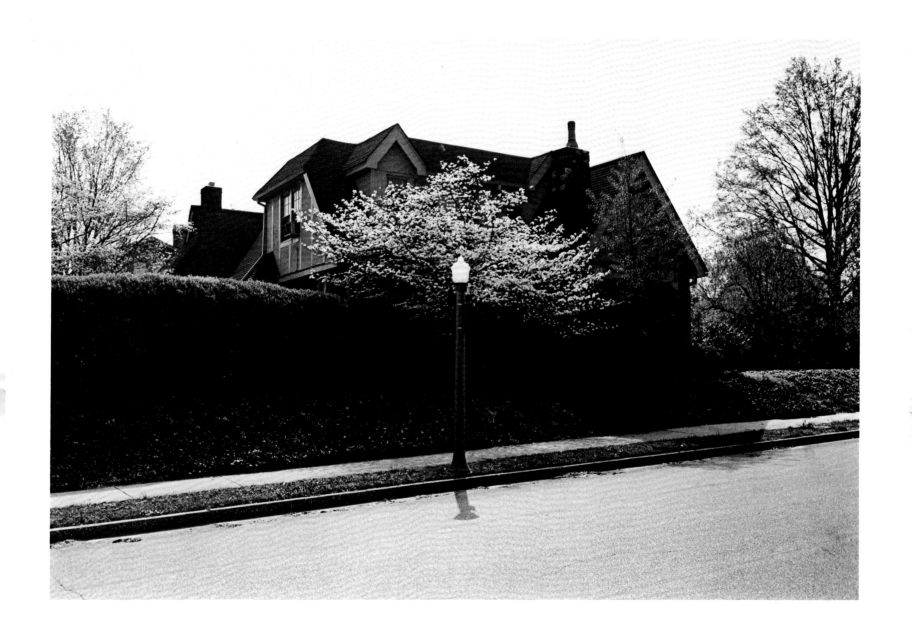

LEE FRIEDLANDER. *Memphis, Tennessee*. 1973. 7 x 10¼ inches. The Museum of Modern Art, New York. Gift of Mrs. John D. Rockefeller 3rd

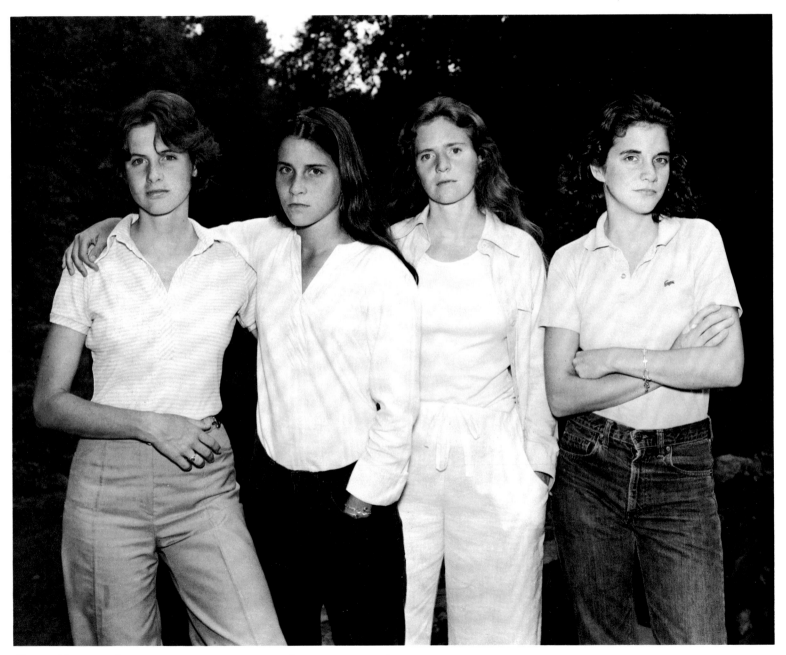

NICHOLAS NIXON. *Heather Brown McCann, Mimi Brown, Bebe Brown Nixon, and Laurie Brown, New Canaan, Connecticut.* 1975
7¾ x 9¾ inches. The Museum of Modern Art, New York. Gift of the photographer

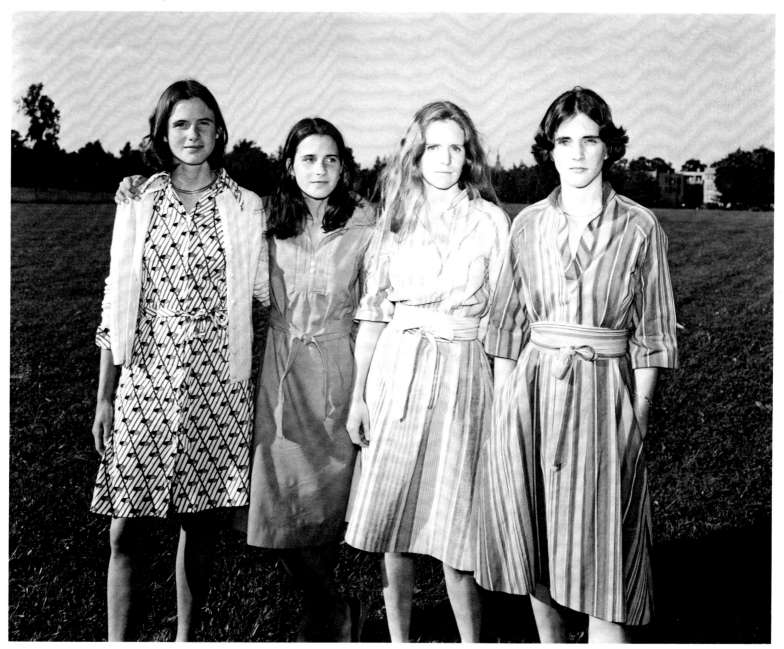

NICHOLAS NIXON. *Heather Brown McCann, Mimi Brown, Bebe Brown Nixon, and Laurie Brown, Hartford, Connecticut.* 1976
7¾ x 9¾ inches. The Museum of Modern Art, New York. Purchase

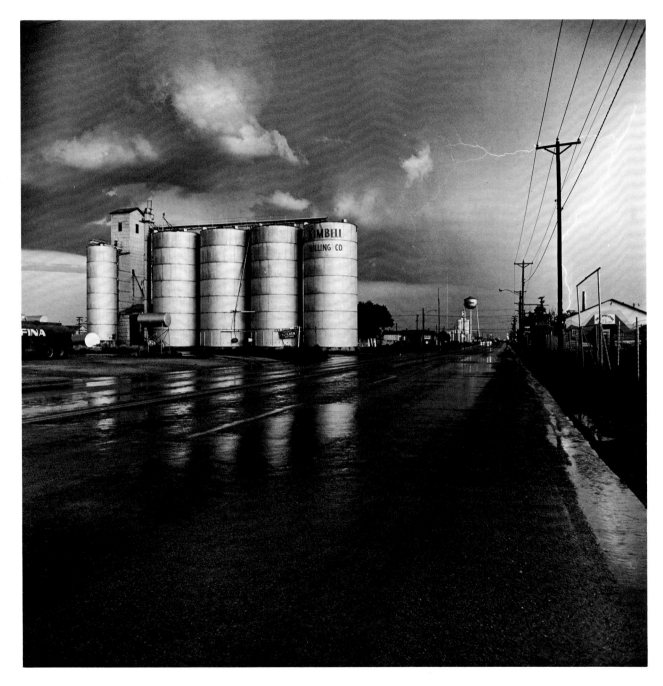

Index to the Artists

All the artists represented in this book were born in the United States, unless otherwise specified in the list below. Page numbers with asterisks indicate works in color.